THE SOUTH IN COLOR

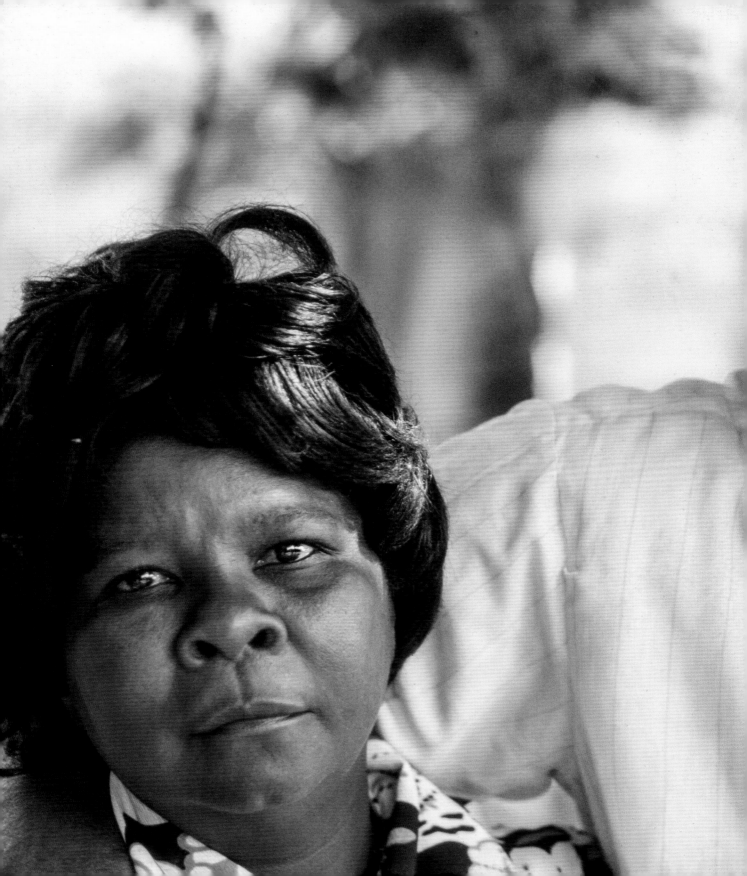

THE
UNIVERSITY
OF
NORTH
CAROLINA
PRESS
Chapel Hill

WILLIAM FERRIS

THE SOUTH IN COLOR

A VISUAL JOURNAL

Foreword by TOM RANKIN

Manufactured in China

Designed by Richard Hendel

Set in Linoletter

by Tseng Information Systems, Inc.

The University of North Carolina Press has been

a member of the Green Press Initiative since 2003.

Jacket illustration: Unidentified fireworks salesman,

Leland, Mississippi, circa 1976. Photograph by Bill Ferris.

Library of Congress Cataloging-in-Publication Data

Names: Ferris, William R., photographer. | Rankin, Tom, writer of

foreword.

Title: The South in color : a visual journal / William Ferris ; foreword by

Tom Rankin.

Other titles: H. Eugene and Lillian Youngs Lehman series.

Description: Chapel Hill : The University of North Carolina Press,

[2016] | Series: H. Eugene and Lillian Youngs Lehman series | Includes

bibliographical references and index.

Identifiers: LCCN 2016012009| ISBN 9781469629681 (cloth : alk. paper) |

ISBN 9781469629698 (ebook)

Subjects: LCSH: Southern States—Pictorial works.

Classification: LCC F210 .F47 2016 | DDC 975.0022/2—dc23

LC record available at http://lccn.loc.gov/2016012009

This book was published with the assistance of the
H. Eugene and Lillian Youngs Lehman Fund of the
University of North Carolina Press. A complete list
of books published in the Lehman Series appears at
the end of the book.

FOR MOTHER,

whose compassionate

spirit hovers over this

work, who taught me

the meaning of love

and understanding

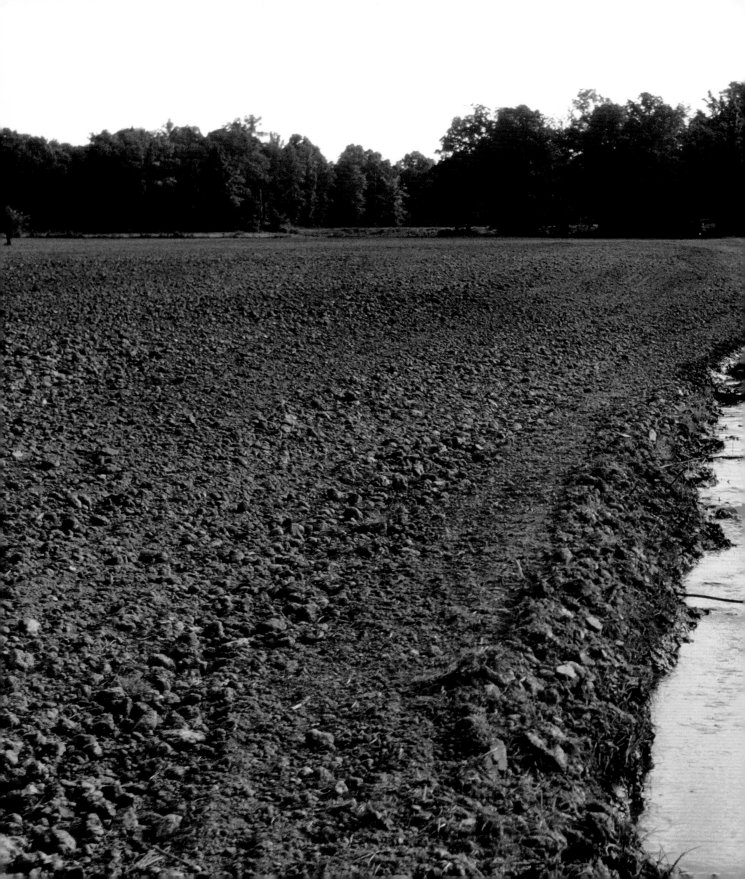

For Mother
(1918–2014)

My parents both died,
In the same room.
He faced west.
She faced east,
Thirty-six years apart.
When Daddy died,
Mother remarked that,
It was the last time,
He would make the drive,
Down the hill.
Like Daddy, this week,
She traveled,
Past that same familiar view,
Of woods and pastures,
Through rows of
Watermelon crepe myrtle,
Planted by our grandmother,
Past Rose Hill Church,
Distant space above,
Firm earth below.
The farm they knew,
And loved so long,
Bid them both farewell,
Safe journey down the hill.

—WILLIAM FERRIS

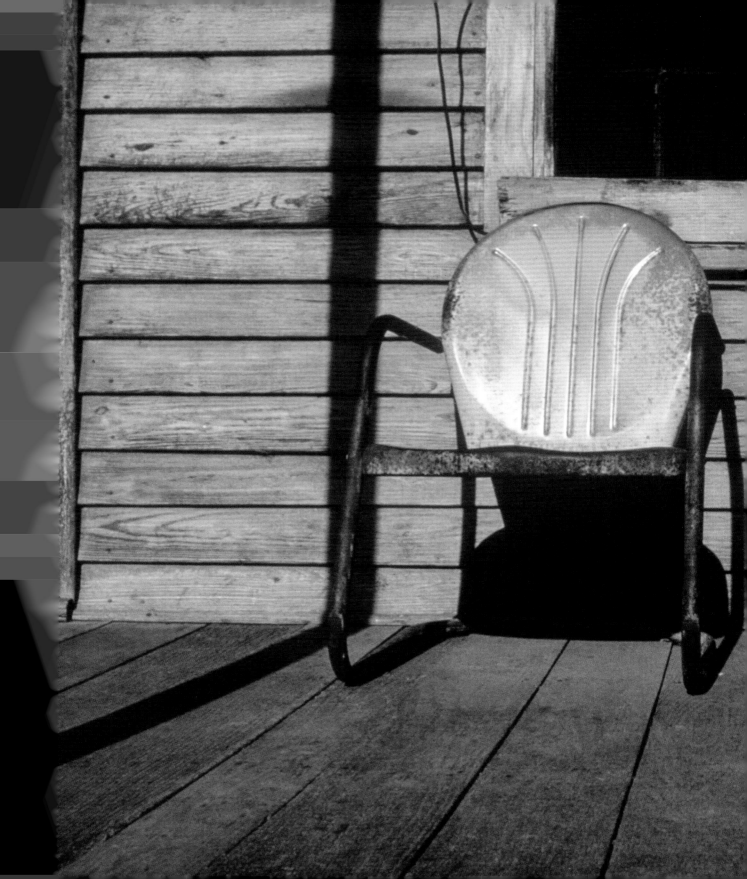

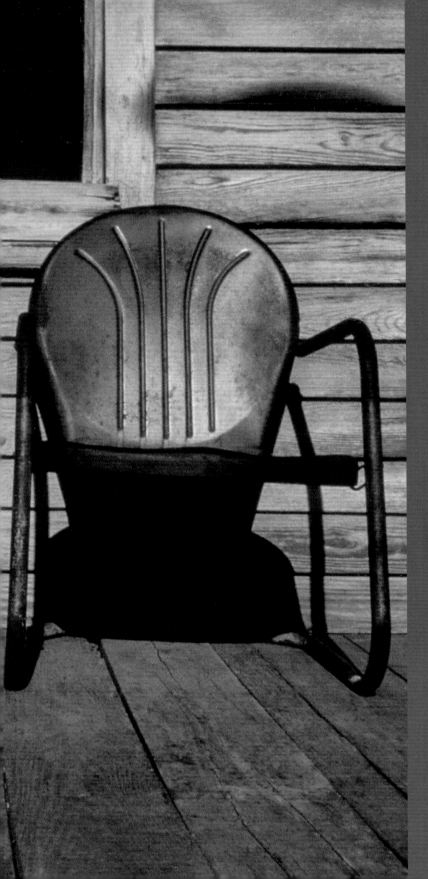

CONTENTS

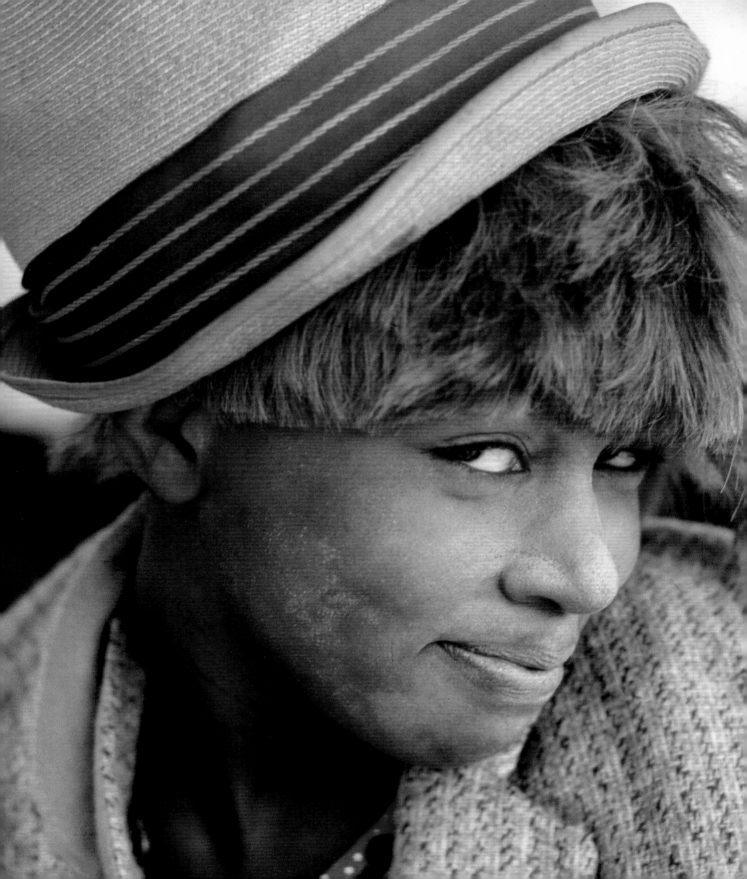

FOREWORD

In the middle of the 1990s, Bill Ferris and
I caught a train—named the City of New
Orleans—in Batesville, Mississippi, for a quick
trip south to New Orleans. We were going to
New Orleans to meet with the Delta Queen
Steamboat Company, with an overnight stay
and dinner meeting planned to discuss possible
educational collaborations between the Center
for the Study of Southern Culture at the
University of Mississippi and the company's
many riverboat cruises up and down the
Mississippi River. We were on a fundraising
trek, really, with me along simply as supporting
cast to help in the effort. Settling into our train
seats side by side, we gradually pulled out of
Batesville headed toward Jackson. The City of
New Orleans route has changed since then,
but at that time Amtrak essentially mirrored
Highway 51, running through Grenada and
then Winona, from there on through Durant
and Canton, then making a short stop in
Jackson before continuing on to New Orleans.
The weather was splendid, the light near
perfect, and Bill and I talked as we rumbled
over the slight Mississippi hills. We both
brought work to do on the train, things to read
and correspondence to answer, but it's our
talking and looking I most remember.

Train travel offers such a distinctive point
of view on the landscape and towns of all
sizes, with the train car window providing a
kind of perpetual photographic frame around
the world passing by. We relished seeing
the backsides of businesses, the industrial
spaces and lumberyards in even the smallest
of places, the backyards of communities, all

xi

those crossroads of commerce and culture that are often invisible to car travelers. The fronts of houses and businesses most often face the roads, with the other side so often out of sight. We talked about Mississippi counties and said their names as we left one and entered another: Panola, Tallahatchie, Yalobusha, Grenada, Montgomery, Carroll, Holmes, Madison, making our way into Hinds County, home to Jackson, the state capital.

We both knew people from various communities along the way and seeing just a place name would frequently call forth a recollection, character, story, or friend. Stories mixed with landscape, merging with ideas for how we might talk to the people from the Delta Queen Corporation. Only in retrospect does it cross my mind that we should have thought of Bill's dear friend (and his father's friend before that) Eudora Welty and how she had written in *One Writer's Beginnings* of her own train ride with her father: "Side by side and separately, we each lost ourselves in the experience of not missing anything, of seeing everything, of knowing each time what the blows of the whistle meant."

From Jackson we headed into the Piney Woods region of the state, feeling the topography shift as we got a very quick glimpse of the Pearl River near Byram, then angling through Terry and Crystal Springs. At one point we figured we were just a thirty-five-mile drive west of the Ferris farm in Warren County.

We marveled at a beautiful herd of Hereford cattle accompanied by a regal Angus bull, and our conversation turned to what Bill's family was raising on their farm outside of Vicksburg. We were passing through the land of Luster Willis, the painter, carver, and visionary artist whom Bill had documented in the 1970s and included in his book *Local Color: A Sense of Place in Folk Art*—and whose work is seen in two of Bill's photographs in this book, *The South in Color*. Willis's work has always impressed me for the combination of his visionary imagination and his reflections on everyday struggles. "I just get to thinking what I can make," Willis told Bill, "what I can draw or paint, and I compare it to life as I know it."

Every place we passed on our train trip that day seemed to foster our own comparisons, reminding us of connections, ideas about place, and about how the creative imagination can render the smallest things as consequential, as enlarged. We could have looked and talked forever, it seemed, with Bill never running out of associations with or references to a place he had been or a person he knew or an experience to recount. When we passed through McComb we talked about our mutual hero and friend Will D. Campbell, who grew up in Amite County, labored miraculously in the vineyards of racial reconciliation and justice, and who had recently come through Oxford to speak to our southern studies students at Ole Miss. Soon after that we crossed the Mississippi line, passing through Hammond, Louisiana, and onward through the bayous and over the water into New Orleans.

When Bill Ferris and I talk it is so often about the confluence of place and memory, about the same sorts of connective tissue he

has always recognized no matter how far he has to wind and twist to locate the common associations. Sometimes the lines are straight and sharp and easy to see, and other times Bill finds a way to illustrate a complex diagram with the many overlaps he knows and feels. Anyone who has sat and talked with him for any length of time knows this. He relishes acknowledgment of the distinctiveness of creativity, individuality, and place in particular lives, and loves nothing more than what he might find in the narrow bends on the roads of memory. For whatever he discovers in one place he tries to chart the connection that exists far beyond what we initially understand. The stories never end for Bill; the circle always seems to widen. Never ending, too, is his search for the relationships, the lineage, the very urge to fit the pieces together, creating a kind of order and well-surveyed map from what earlier appeared fragmented and random.

Bill Ferris began photographing at an early age, like so many other photographers have. He saw the potential in picture making by watching older members of the family, particularly his mother, make and keep photographs. Shelby Ferris, Bill's mother, was an inveterate writer, photographer, and keeper of family lore and history. Bill explains that his mother always wrote letters to any of her five children who were away from home. If more than one child was off at school or traveling, she would use carbon paper to produce duplicate letters to send them; if all five Ferris children were away, she would resort to four sheets of carbon paper.

A child might receive carbon copy number one or copy number four, but all received a copy, all received the news from home. Each holiday season Shelby Ferris made photographic Christmas cards, the family portrait mailed far and wide to friends, the photograph carrying its own kind of news and time stamp of the passing year. The words, the photographs, and the stories told merged to deepen the family connections and affirm the power of the showing and the telling.

Who knows exactly when Bill Ferris began to understand photography as something "bigger" than a family pursuit. And just saying that calls forth the idea that perhaps he's never seen it as different from a family pursuit—but rather has seen it as a means of expanding the family, widening it, taking in more relatives. The purity and innocence of the family photograph still inform the way Bill sees the camera in action and the photograph in time.

One photograph of Bill taken by his mother shows him with a fawn in his lap, both the deer and Bill expressing a tender and raw innocence, an uncanny ease with each other. Bambi, the fawn that the family had rescued and compassionately raised, embodies that vulnerable wildness that so often is accompanied by quiet calm, and this picture is emblematic of the easy, natural directness of so much of Bill's own work.

The Ferris house was well populated with family photographs, and Bill to this day relishes his memories of the plethora of stories older family members would tell him about this person or that person pictured in

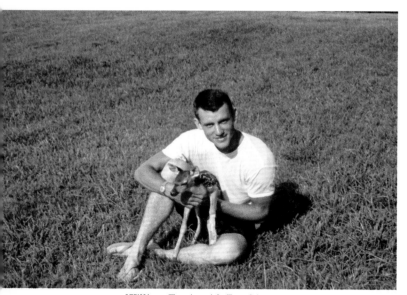

William Ferris with Bambi, 1963.
Photo by Shelby Ferris Sr.

a framed photograph on the wall. As he grew older, he visited tenants on the family farm and got to know them through their stories. He recalls realizing that they had few, if any, family photographs. His earliest impulse to photograph people on the farm came in part from this recognition, this sense of an imbalance whereby some homes had more photographs—more reflections of history—than others. He would make photographs where few photographs existed, and, by sharing them with the families, in his own small way help fill in those gaps, do his part to resist the drift of anonymity by documenting those families living on the family farm, to discover ways to tell those important untold stories.

He began making tape recordings of many people on the farm before he made pictures, with the story and the voice always leading him, always seemingly the first attraction. Those stories, some preserved on his early tape recordings and others remembered and recounted, reveal the particularities of time and task, of song and belief, themes so integral to all the documentary work he has done throughout his career. Could the camera have begun for Bill simply as way to engage, the resulting photograph an offering of evidence of what had transpired between him and those he felt drawn to? The photographer never fully knows the sources of intuitive picture making, but what we witness from Bill's work made in the formative years revealed in *The South in Color* is that the camera offered a way to continue the kind of documentary

engagement that began at home on the family farm. As Bill moved through Davidson College, then graduate school in Chicago and study in Ireland, and eventually came to study folklore at the University of Pennsylvania the camera was always at his side.

My favorite photograph of Bill Ferris is one his father took of a loaded hay truck, that wonderful moment of respite when the crew drives from the field to the barn before having to again handle each bale. White and black workers on top of the stacked hay, comfortably perched with what had to be a stellar view of the Big Black River bottom spread before them. Bill sits on the hood of the truck, out front and alone, and yet very much a part of this young crew doing near timeless agricultural work. When the truck moves Bill will have the wind in his face, an unobstructed view of the road ahead, a clear-eyed sight of the way to the barn. Bill told me he really wasn't suited for farm work, something pretty obvious to his father when he was working alongside Bill. "I couldn't find a 3/4-inch wrench in the toolbox," Bill would say with a deeply self-deprecating tone, "and realized at some point I needed to find something else to do." That "something else," however, is informed and saturated by those experiences there on the farm, by the toolboxes he searched, and by those rides to and from the barn. Those were illuminating lessons that could come only from a long day hauling hay in the Mississippi sun. His respect for work, for the manual labor and genius of the handmade, can be traced to those earliest days.

Bill begins this book like he began his

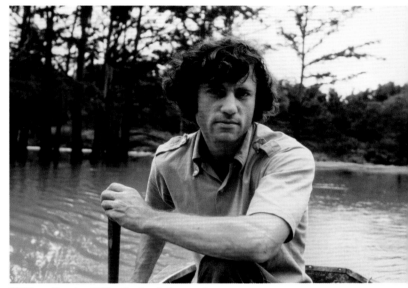

William Ferris at Wes Carter Lake, 1976.
Photo by Shelby Ferris Sr.

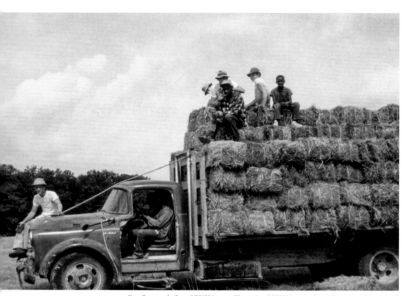

Left to right: William Ferris, William Appleton, "Little" Isaiah Brown (driver); *left to right, on hay*: Richard Lambert, Grey Ferris, George Martin, Ben Guider, Isaiah Brown Jr. Hay truck in hay field, Fisher Ferry Road, Warren County, Mississippi, 1963. Photo by William Ferris Sr.

photographic work—close to home. His earliest color images come from the most familiar place and the most deeply familiar people around him. The first portrait of Robert Appleton that appears here is not about catching Appleton at work or momentarily unaware of the camera's gaze. Instead Bill delivers a portrait in which he and Appleton seem in complete dialogue at the precise moment of exposure, eyes connecting, revealing a steady intimacy and ease that is more about the invisible interior of the man than it is about the exterior. But it is also clearly an honest portrait of the difference between the two men, Appleton as a tenant on the Ferris farm and the photographer destined to travel and explore widely. So many of Bill's portraits— whether of his own family or others he met and collaborated with in the 1960s and 1970s— reveal as much about the emotional core of individual relationships as they do about the visible nature of the cultural landscape of place.

The photographs in this book are carefully considered from an expansive archive of choices that were not necessarily thought of as part of a "project" or a book while Bill Ferris was taking them. I really don't think Bill knew exactly why he was making so many pictures, often carrying two cameras, one with black-and-white film and the other with color slide film. To be sure, he knew he was "documenting," and he confidently knew by the early 1960s that his work was about showing us and telling us intimate details of ordinary lives, helping continue James Agee's ideas in praise of "human actuality," the ways in which all the details are infinitely important. He

was intuitively collecting, making his camera part of his ongoing dialogue and engagement first with home and then with the larger story of the American South. He used these color images in classes and lectures, exploiting the descriptive power of the Kodachrome and Ektachrome transparency to take viewers into moments they might never experience on their own or to show them the power of vernacular art, combining his images with stories, interpretations, and field recordings.

Many others were photographing the region at the same time, but coming at it from very different perspectives and with diverse points of view and agendas. Well versed and influenced by his graduate training in folklore and ethnography, Bill is equally influenced by his understanding of literature and storytelling, his reading of Eudora Welty, Richard Wright, William Faulkner, Ernest Gaines, and Alice Walker, to name just a few. But his biggest influence may well be his own intuition about the vast political and cultural shifts at work as he moved into spaces and relationships that he instinctively felt were powerful, revelatory, unseen, in need of the kinds of acknowledgment and affirmation that documentary art can often provide. It is that perception and tenacity we witness here, not a rambling stream of consciousness in pictures, but a kind of visual journal of where he's been, what he's seen, and what he knows in his head and heart that we should also see and know.

How do you make fresh pictures of a place so often photographed, that place we know as "the South"? You start early and you keep at it, you stay in it for the long haul while others come and go. When Bill interviewed Eudora Welty and Walker Evans about their photographs, he might have discovered reasons to put aside his own camera and simply attend to the work they had already done, to serve more as a photographic historian of the region than as another maker of a deeply personal photographic art. Instead he used his understanding of their work to influence his own, his particular placement in teaching, in the disciplines of folklore and Southern Studies, in his Warren County, Mississippi, background. He built upon this foundation to locate his place in the world of lyric documentary photography.

More often than not Bill Ferris identifies himself as a folklorist and scholar rather than as a photographic artist. But with this rich body of color work we see the compelling wonder and complexity of his photographic vision. To paraphrase William Faulkner when talking about writing ("Don't be a writer; be writing"), Bill seems to have worried little about *being* a photographer and simply kept photographing. And then photographed some more.

Bill tells a revealing story of the first time Charlotte Capers, the longtime head of the Mississippi Department of Archives and History, showed him a selection of Eudora Welty's photographs. After a talk Bill gave in Jackson in 1967 about his documentary work on the blues, Capers took him to a room and showed him Welty's photographs. Bill recalls the beauty of the work and the affirmation Welty's images offered for what he was doing,

reinforcing the value of his own photography and recording, all at a time when many in the white community questioned his committed interest in documenting black life and art. Finding that kind of encouragement and interest close to home in Mississippi combined with what Bill knew in his own soul and was hearing from people across the country.

Here, Bill's color photographs offer a kind of visual diary, but not tracked by chronology only. This photographic narrative is also a sequence of those decisive moments of exposure he thought we should see, what he wanted to share with the world, what he hopes a photograph can carry forward from the ever present to the lasting resonance of documentary and artistic expression. It is "now or never," as Welty said so powerfully of the photographic moment in an interview for her 1989 book, *Eudora Welty: Photographs*. Bill has always understood the urgency of the moment, fully occupied in the distinctive slivers of the present, reacting photographically with complete understanding that he can return to the work later, but that there may be only one chance for a given picture, a particular moment of artistic confluence.

Bill Ferris's photographs of the 1960s and 1970s reflect the world that made him, the world that nourished him, and also the world that caused him to want to see more, to travel, to leave. Even in leaving for school and career he has always returned, always circled back. Gary Winogrand famously said that he made photographs "to see what something looks like photographed." There is nothing

so abstract for Bill, as his photographs are never divorced from his feelings for a place, from his own life and the lives of those he has met along the way. Merle Haggard's line from his song "My Favorite Memories" comes to mind when talking with Bill: "Everything does change except what we choose to recall." His photographic memory—and that's what we have here in these pages—is a large part of that recollection. It's a story about affirmation, about Bill's reverence for his many worlds, but also very much about the search for photographic goodness and light in the tangles of regional divisiveness, prejudice, and exclusion.

A series of photographs like these help us see with fresh eyes where we've already been; help us remember, yes, but also prompt us to discover a new clarity of vision, a way to re-imagine even the most familiar of past places. "We come to terms as well as we can with our lifelong exposure to the world," wrote Eudora Welty in *One Time, One Place*. "If exposure is essential, still more so is the reflection." The joy of this work is the deeply considered reflection, a series of powerful images that bear witness to the range of places, people, and moments Bill found resonant and relevant. This is the photographic work of a great listener and observer. Bill Ferris's images, artfully revealing such nuanced sequence in place and time, make us feel we are learning our own history yet again while simultaneously discovering brand new territories we had no idea existed.

Tom Rankin

THE SOUTH IN COLOR

INTRODUCTION

A VISUAL JOURNAL

Memory is a strange thing in the South. Some never forget. Some want to forget. Others simply cannot remember. For each, photography plays an essential role.

These photographs document my work as a folklorist and my life as a southerner. They begin with scenes on the farm where I grew up, and they reflect my ambivalent relationship with both beautiful and haunting worlds that always surround me. My photographs reflect that tension as they engage the region with a knowing, unflinching eye. I am acutely conscious of the power of southern images and symbols after the massacre of nine black southerners at Emanuel African Methodist Episcopal Church in Charleston, South Carolina, on the evening of June 17, 2015.

This book addresses my complex relationship with the South. I bring an appreciative but wary eye to its people and their history. Having grown up on a farm in rural Mississippi, I feel the South's power and presence in deep, intimate ways.

Unlike photographers who passed through and photographed the region for brief periods, I worked with my camera in the South for more than six decades. I witnessed violent social change during the 1960s and 1970s. My photographs track race relations in the South, a region where racial hatred and violence refuse to disappear.

As a child, my understanding of race began on the farm where I grew up in rural Mississippi in the 1950s. It deepened when I participated in the civil rights movement

1

and was a conscientious objector during the Vietnam War. I taught at Jackson State University and in the Afro-American Studies Program at Yale University in the 1970s and was shaped by those experiences. My deep feelings about social issues and racial injustice inspired these photographs.

Race is a central theme in my photography. It is impossible to understand the American South apart from the intimate, enduring presence of race in the region. With my camera, I captured a people—both black and white—whose lives are defined by the sinister presence of racism. Those people and their experiences are the subject of these color photographs.

The good photographer is she or he who bears witness to the moment by capturing it on film. These images were taken where I grew up in Mississippi along Highway 61. I did not choose the places where I photographed. They chose me. I was born into their midst and have spent my life trying to understand them.

MY FIRST PHOTOGRAPHS

This book is clearly the most autobiographical work I have published. Its photographs document my own family and other families on the farm where I grew up. Those images are intimately linked to my memory.

As a child I remember that Robert Appleton drove a wagon pulled by two mules. Today Appleton and his mules are gone. I recently tried to recall the names of the mules and could only remember Mamie. Struggling to remember the second mule's name, I felt as though I were falling through space and time. I called William Appleton, Robert Appleton's son, and he told me the second mule's name was Sam. How could I forget? Today, Robert Appleton's wagon is parked in a stall inside the horse barn where he left it.

When I look at my photograph of Robert Appleton, his image is like a parachute that cushions my fall. It helps me to focus, to reconnect with Appleton and his world. He looks back at me, and I remember that moment when I took his picture. Appleton's photograph helps me look both forward and backward.

I can trace my life through my photography. I took my first photograph at the age of twelve, when my parents gave me a camera for Christmas. I tore the holiday wrapping paper from the box and inside found a Kodak Brownie Hawkeye with its flash attachment. I opened my first roll of film, pulled it across the back of the camera, and attached it to an empty reel. As I photographed our family at my grandmother's Christmas dinner table, I marveled at the click of the shutter and the bright flash.

Connie Wood, a Vicksburg pharmacist, mailed my first roll of film off for processing. A few days later, an envelope returned with my negatives and prints. Thirteen years later, my younger brother Grey taught me to process 35mm black-and-white negatives and to print photographs in a small darkroom that he and I created in an abandoned building next to our home. Grey introduced me to the magic of photography as we printed black-and-white images together.

In 1955, I photographed a baptism as African

American worshippers from Rose Hill Church gathered on the banks of Hamer Bayou near my home. The close, intimate photographs of my family's Christmas dinner and the more distanced images of the baptism launched my work as a photographer. My journey to capture people and their worlds through photography began with those moments and continues today, more than sixty years later.

The photographs in *The South in Color* begin on the farm where I grew up in Warren County, sixteen miles southeast of Vicksburg, Mississippi. I cannot remember when I shifted from the pleasure of taking photographs of family and friends to using the camera as a tool to capture people and places I would later describe as "the South." Surely there was a moment when I began to search for such meaning in my photographs. Or perhaps it began when I took that first image.

As an undergraduate student at Davidson College in the 1960s, I discovered hauntingly beautiful photographs of my hometown of Vicksburg, Mississippi, that were taken by Walker Evans and Frederic Ramsey Jr. from the 1930s to the 1950s. Their work inspired me to take my camera and photograph familiar worlds that I had known since childhood.

Black-and-white photographs taken by Walker Evans and those of Eudora Welty, whose work I discovered several years later, defined documentary work for me. Their images cast a long shadow across my own and strongly influenced my personal view of documentary photography. Their black-and-white photographs conveyed a stark honesty that resonated with my effort to explore my own world through the camera lens.

Graduating from the Kodak Brownie camera I was given in 1954 to a Pentax 35mm camera I purchased in 1967, I photographed landscapes, cityscapes, and portraits. I embraced the camera as a means to engage the world around me, and documenting people and places through photography became part of my DNA.

I shot thousands of photographs during my time as a graduate student in folklore at the University of Pennsylvania (1967–69) and then as a professor at Jackson State University (1970–72), Yale University (1972–79), and the University of Mississippi (1979–97), as chairman of the National Endowment for the Humanities (1997–2001), and now as a professor at the University of North Carolina at Chapel Hill (2001–present). During each period of my life, I compulsively photographed with both black-and-white and color film.

I created a visual journal with my camera and pursued my lifelong passion to document the American South through photography. From the first photograph I took in 1954 to the present, I used both color and black-and-white film. Over the years, I continued to take color photographs, even though publishers refused to include color illustrations in my articles and books because of the expense of printing them. When McGraw-Hill published my book *Local Color: A Sense of Place in Folk Art* in 1982, they reproduced my color photographs of artists and their work in black and white.

In the 1970s and 1980s, I carried two Nikon 35mm cameras—one loaded with black-and-

white film, the other with color—and I took similar pictures with each camera. I did so out of a love for color images and my belief that one day those images would be published.

The ground under me shifted when I embraced digital photography ten years ago. When my old 35mm Nikon camera could not be repaired, I photographed with my Blackberry and, more recently, with my iPhone 6 Plus. I now upgrade to each new generation of iPhones as they improve their cameras. With my iPhone and a small tripod in my shoulder bag, I still photograph and film the worlds around me. Digital equipment has now replaced film in my life, and I rely heavily on it. When 60,000 digital photographs and films recently overwhelmed my iPhoto software, I moved them to Adobe Photoshop Lightroom on my Apple laptop computer.

MY WORLD TURNS TO COLOR

The South in Color is the third volume in a trilogy of my work on the American South. Two earlier publications—*Give My Poor Heart Ease: Voices of the Mississippi Blues* and *The Storied South: Voices of Writers and Artists*—feature my black-and-white photographs of blues musicians and of southern writers and artists. In those books, photographs illustrate and support the text. *The South in Color* turns the table and allows photographs to establish their own visual narrative. Apart from a series of postcards and the covers of three earlier books—*Afro-American Folk Art and Crafts*, *Local Color*, and *The Storied South*—my color photographs have never been published.

Like many photographers who documented the South, I privileged black-and-white photography as the truest, most authentic medium for ethnographic work. Although I took more than 5,000 color negatives and slides, only black-and-white photographs illustrated my books and articles.

I viewed color photographs as stepchildren within the documentary world and associated color images with magazines sold at newsstands. Black-and-white photography, by contrast, was the medium of choice for most of the Farm Security Administration documentary photographers, including Walker Evans and Eudora Welty. Even William Eggleston, the acknowledged master of color photography, took important black-and-white images of Parchman Penitentiary inmates and bluesman Mississippi Fred McDowell as a young photographer. It was unusual to do documentary photography with color film in the 1950s, 1960s, and 1970s, which makes this book especially important. These images offer a moment of clarity and discovery to our understanding of the South and its worlds during that era.

Throughout my career as a teacher and public lecturer over the past forty years, many of the images in this book illustrated my presentations. In darkened rooms, my color slides dropped from their carousel slide tray into a slide projector as I spoke about the American South.

It was through my friendships with William Christenberry, William Eggleston, and Walker Evans in the 1970s that I began to view color

photography as an art form. While teaching at Yale, I befriended Walker Evans, who at that period of his life took color photographs with his Polaroid camera. Evans introduced me to Christenberry, and they both encouraged me to think seriously about color photography. I met Eggleston at his home in Memphis in 1975. Stunned by the beauty of his work, I invited Eggleston to speak to my students at Yale just after the historic exhibition of his color photography, *William Eggleston's Guide*, opened at the Museum of Modern Art in 1976.

Evans, Christenberry, and Eggleston taught me to view color photographs as more than teaching tools. The color photograph became a canvas on which the pallet of color was as important as the subject itself.

Reflecting on his own photography, William Eggleston told me, "I think a series of photographs is like a novel.... If a person went slowly through that body of work, it would be roughly like reading a novel." Each image in *The South in Color* captures a story. We should read a visual image just as we read a literary text. While each image in this book has been carefully selected, that photograph achieves a stronger narrative quality when viewed as part of a sequence of images within its chapter and within the book as a whole. Sequencing these photographs endows them with a narrative power. It unleashes their visual voice and allows them to achieve a sense of motion and story. Viewed together, they deepen the furrow of how we understand place.

William Christenberry, William Eggleston, Walker Evans, and Eudora Welty shaped my work as a photographer in more ways than I can count. Each welcomed me into their lives and generously encouraged my work, and their photographs of the American South inspired my own. I was blessed to meet them and to discover their photography early in my career. I shared a lifelong friendship with Evans and Welty, and I continue to do so with Christenberry and Eggleston. Each took distinctive photographs of people, buildings, and landscapes that are instantly recognizable. When I take a photograph, I often reflect on how they might have done it. Their work always inspires my own.

The collective canon of their photography underscores the enduring power of photographers and their complex relationship to the American South. Whether born in the region—as Christenberry, Eggleston, and Welty were—or visiting from outside—as did Evans— they captured images that forever etched the South within the photography world. By lifting their camera, each viewed their subject with a studied distance, a distance that I take seriously in my own work.

As a photographer of the American South, I sought the Holy Grail—that single image that captures the region in its fullest, most engaging expression. I pursued that quest knowing that the South and its diverse worlds can never be contained within a single photograph. The viewer best discovers the region through a montage of images that—when viewed together—offer a richer, more nuanced understanding of the South than any single photograph can deliver.

This book exploits the unique power of color photography to reveal the American South. Unlike stark black-and-white pictures, color photographs exude a warmth, an accessibility, an animation that invites the viewer to engage with them. Color photographs of faces and landscapes make us feel present in the moment. They actively draw us in, as we see afresh the people, their homes, and familiar roads and shared spaces. These worlds resonate with our memory. Like family members who reach out and touch us on the cheek, color photographs welcome us at their table, and we talk.

Color photographs capture the deep reds and yellows of sunrise and sunset that we see ever so briefly as the long light falls across the Mississippi Delta, through the hills, across the rough bark of tall pines, onto white-washed boards of churches and hand-painted signs whose bright colors mimic the natural sunlight. Within the color photograph natural and manmade worlds blend indistinguishably into a single fabric that strikes at the heart of the viewer. The color photograph conjures our memory and connects past and present in that single, enduring moment captured on film.

SELECTING PHOTOGRAPHS FOR THIS BOOK

To find the South is an elusive task, and photography is the tool I use for that search. My photographs track the region through its landscape, buildings, and people. They offer an intimate personal encounter with people and their communities. If we can discover

the universe in a grain of sand, we can surely parse the American South in a photograph. The images that follow are grouped into five bodies of work that I photographed.

"The Farm" depicts where I grew up in rural Mississippi. Its black and white families inspired my career as a folklorist and documentarian, and they are the subject of my earliest photography.

"Portraits" features people whom I met and photographed. They capture prison inmates, quilt makers, and roadside vendors as they deal with daily life.

"Buildings" includes sacred and secular worlds of churches, homes, and blues clubs, structures that are intimately associated with the American South.

"Handmade Color" explores hand-painted signs, murals, and folk art that vividly animate homes and public buildings that I visited.

"Roads Traveled" is a reflective look back at places I traveled with my camera in hand.

This book tracks my two deep, abiding loves—photography and the South. These images help me understand how place relentlessly defines people. As I grew older, I saw and photographed my world differently. Time defined me and my work as a photographer.

I try to achieve photographic intimacy by embracing each person with whom I work as if she or he were part of my own family. I want to immerse the viewer in color photographs that establish a visual narrative through images of people, buildings, and landscape. This is the world into which I was born, a world that I

have photographed, filmed, and recorded for more than fifty years. These color photographs are inspired by the South's rich storytelling tradition. They are signposts that signal both our past and our future.

Photographs help me understand that the South is drenched in both tradition and change, that its buildings, hand-painted signs, and people are all ephemeral. Each photograph captures an image that one day will vanish. William Christenberry and Walker Evans explained how they similarly wrestled with the changing landscape they photographed. Evans told me, "The texture of unpainted wood is also very attractive to me. . . . When I go out and see those houses painted over, I am dismayed. I don't want them to be painted." Evans's photograph forever fixed that unpainted home in its time and place.

William Christenberry used photographs to track change and the gradual decay of buildings and signs in Hale County, Alabama. Like Evans, he finds "beauty in things that are old and changing, like we all are changing. . . . I continue to seek those places out, and I go back to them every year, until sooner or later they are gone. They have blown away, burned, or fallen down, or just simply disappeared."

My deepest debt is to Eudora Welty, whose short stories I first read as a student at Brooks School, where I wrote my first short story. As an aspiring writer at Davidson College, I was drawn to Welty's use of vernacular speech and wrote several dramatic monologues and a one-act play that was produced. In my writing I created voices that were inspired by those I had read in Welty's "Why I Live at the P.O." and "A Worn Path." Her fiction inspired my modest efforts as a writer. Later, while I was a graduate student in folklore at the University of Pennsylvania, Charlotte Capers showed me Welty's powerful black-and-white photographs after a talk I gave at the Mississippi Department of Archives.

Interestingly, Welty's photography preceded her fiction. Her job with the Works Progress Administration took her "to practically every county in Mississippi. . . . It hit me with great impact to see everything first-hand like that." Photography brought her face to face with the people whose worlds later inspired her fiction. They "provided the raw material. . . . It was the reality that I used as a background." Welty's vision both as a writer and as a photographer helped me frame my own work as a folklorist. I recorded, filmed, and photographed worlds that she knew so well and felt I followed in her footsteps with my camera.

I now understand why Christenberry, Eggleston, Evans, and Welty used photography to ground and anchor place. Photographs are a way to track change, to follow people and places until they no longer exist. We grant them immortality when we click our shutter.

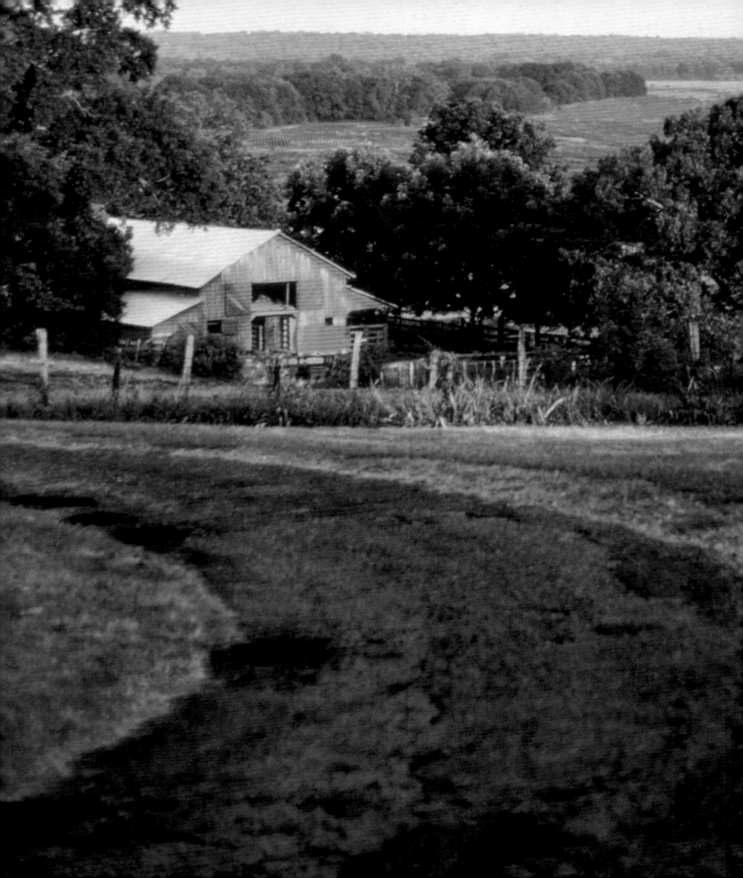

THE FARM

In my family, when we say "the farm" we experience a flurry of images and memories—like a covey of quail rising from the ground—associated with the home where my four siblings and I grew up. The farm has nurtured four generations of my family, and it is the emotional center of my life. Its landscape and the lives of those who live there are intimately associated with my own. The farm is my spiritual anchor, and these first photographs focus on its people and their community.

The farm embraces beautiful, expansive fields, Rose Hill Church—which overlooks those fields—and families whose homes face Fisher Ferry Road, the road we travel to reach Vicksburg. My parents named me, the eldest of five siblings, William Reynolds Ferris Jr. But on the farm, my name is and will always be Billy.

Being born on the farm marked me for life. As a young child, I measured myself against Robert "Shorty Boy" Appleton, an adult, who was afflicted with the condition of dwarfism. Appleton sometimes worked in our yard, and he once asked me, "Billy, if they put me in jail, will you come get me out?"

I replied, "Yes, I will."

Measuring my height against his was a moment that bonded our lives and marked the beginning of a journey captured in this book. First through my eye as a child, then later through the lens of my camera, Appleton's face reflected my own. His expression, like a map, grounded me in our shared time and place.

These photographs reconstruct my experience on the farm and frame its landscape and people with pictures and colors that

help me remember them more clearly. The photographs focus on the families of Robert and Martha Appleton, William and Shelby Ferris, Amanda and Mary Gordon, and Isaiah and Eliza Price.

In these photographs, each person rises like a phoenix and reawakens my earliest memories. As a child, on the first Sunday of each month, Mary Gordon took me to services at Rose Hill Church, where I learned traditional hymns and spirituals. Ten years later, I recorded, filmed, and photographed those church services. I also interviewed my own family and others on the farm to document their lives. I compiled a map of the farm and a genealogy for each family based on those interviews.

Childhood friendships on the farm shaped my understanding of race and my commitment to record both black and white people as a way to honor and preserve their history. These are my first attempts to capture a world I later understood as "the South." My earliest color photographs explore the farm—its landscape and its people at home and at work in fields and at Rose Hill Church.

My father's lifelong passion was to work the land, to clear and improve its fields with his bulldozer. Mother focused on her garden and her kitchen, where she made wild plum jelly each fall and kept the finished jars in her pantry. And Rose Hill Church hovered above the homes of the black families who formed its congregation.

A firm grounding in my own family encouraged me to explore others in compassionate, accepting ways. When we speak about the farm, a strong sense of the past always defines our conversations.

When I was a child, black families worked the land with mules, and a blacksmith ran a forge with its burning coals in a shop where he shod animals and repaired farm equipment. That way of life changed dramatically with the arrival of tractors that plowed long, straight rows of cotton and soybeans. Then the Caterpillar appeared rolling on powerful steel tracks as its blade pushed down trees, built roads, and dug lakes.

When machines replaced mules as a means of farming, many families on the farm moved to Vicksburg, Mississippi, and to Aurora, Illinois, where they sought better lives. These photographs are my way of honoring them and the world in which they lived. I view the families on the farm—black and white—as one extended family. With my camera, I captured the web of their lives over the years, a web that embraces each person featured in this book.

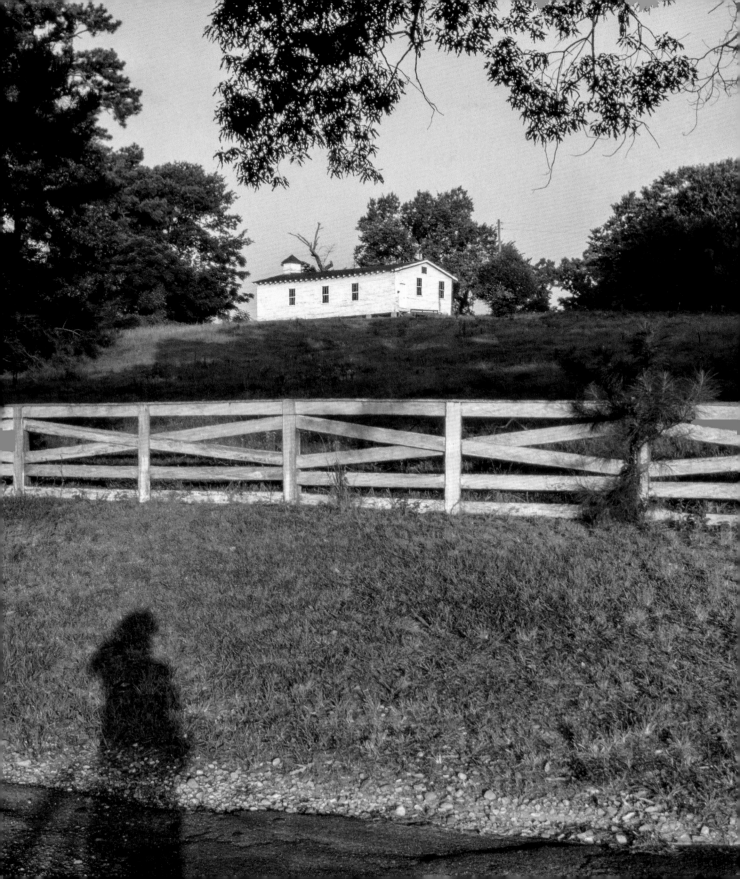

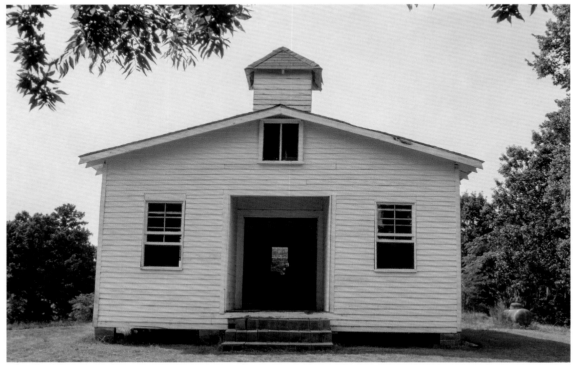

Rose Hill Church, Fisher Ferry Road, Warren County, Mississippi, 1975

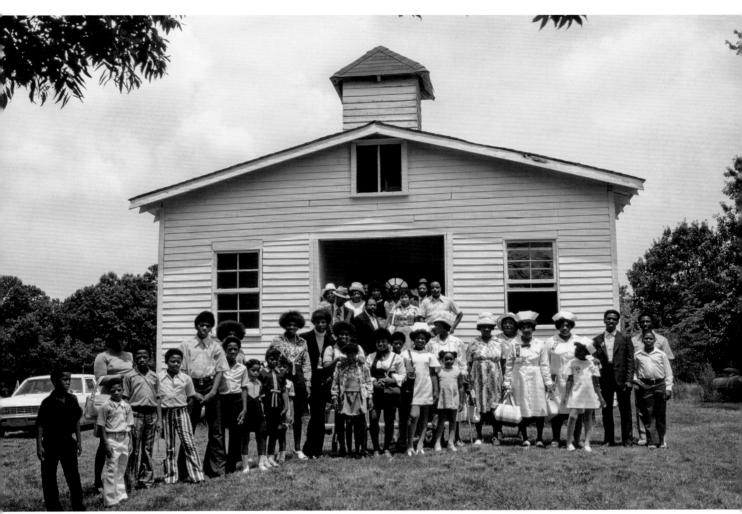

Rose Hill Church and Congregation. *Left to right, front row*: Robert McGowan, Aaron "Dickie" Thomas (green shirt), Elsa "Pee Wee" McGowan (blue dress), Donald McGowan (gold shirt), Eddie McGowan (yellow shirt), John Henry Wright (gold shirt), Alfred Lee McGowan (white shirt), unidentified woman in green, Brenda Fay Appleton (pink and blue dress), Ida Thomas (blue dress with pink in center), Dessie "Ree" Thomas (green dress with white collar), Diane Wright Smith, Larry "L. S." Huband, Mary "Liz" Martin (pink blouse), Mary Ellen McGowan (under Mary Martin's hands), Patricia "Pat" Price (with bag), Allen "Man" McGowan, Annie "Ann" McGowan (white dress and white hat), Cathy McGowan (green dress), Amanda Gordon (standing in white dress behind Cathy McGowan), unidentified lady with bag, Bertilde Smith (yellow dress and white hat), Dora "Red" Russell (white dress with usher ribbon and white hat), Rosie Wallace (white dress with usher ribbon and white hat), Rosie McGowan (small girl in front in white dress with usher ribbon and white hat), Allen McGowan (brown suit and gold shirt), Alton McGowan (gold shirt), unidentified young boy in white shirt. *Left to right, in doorway*: Mary "Monk" Gordon (white hat), Harvey Bass (man in hat), unidentified man without hat, Martha "Tet" Appleton (white dress and hat), Beatrice McGowan (behind Martha Appleton), Betty Ann Thomas (dark blue dress), Lucindy McGriggs (white hat), Mary Lee Appleton (green dress), unidentified man in hat, Steve Washington (gold shirt), Rose Hill Church, Fisher Ferry Road, Warren County, Mississippi, 1975.

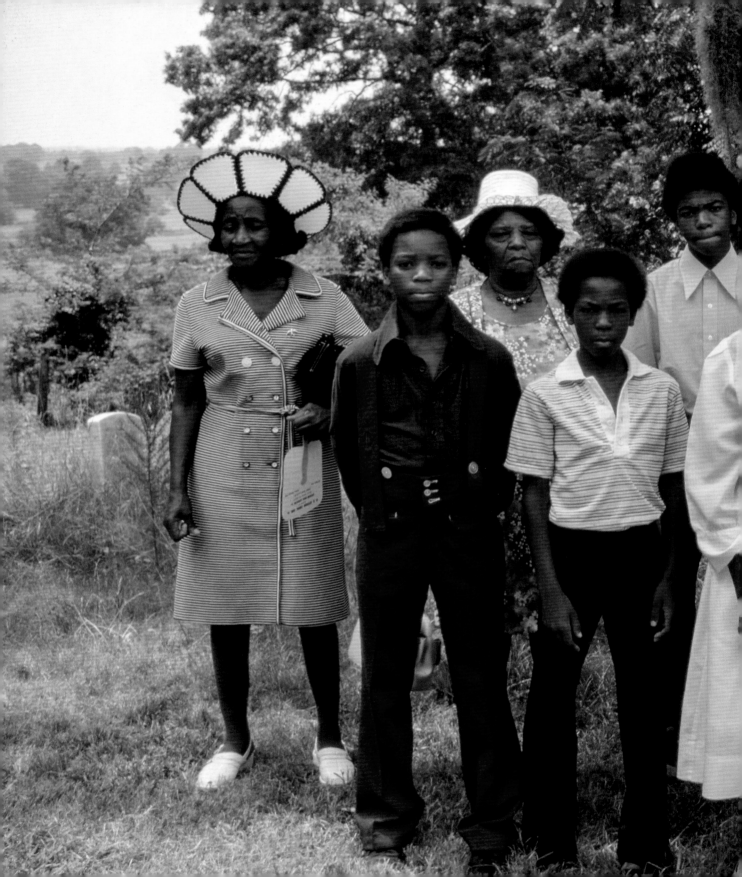

Left to right, rear row: Lucindy McGriggs, Mary Gordon, John Henry Wright, Diane Wright Smith, Beatrice Wright McGowan, Alton McGowan. *Left to right, front row*: Sammy Wright, Alfred Lee McGowan, Amanda Gordon, Mary McGowan, Robert McGowan, Marvin McGowan, Rose Hill Church, Fisher Ferry Road, Warren County, Mississippi, 1975.

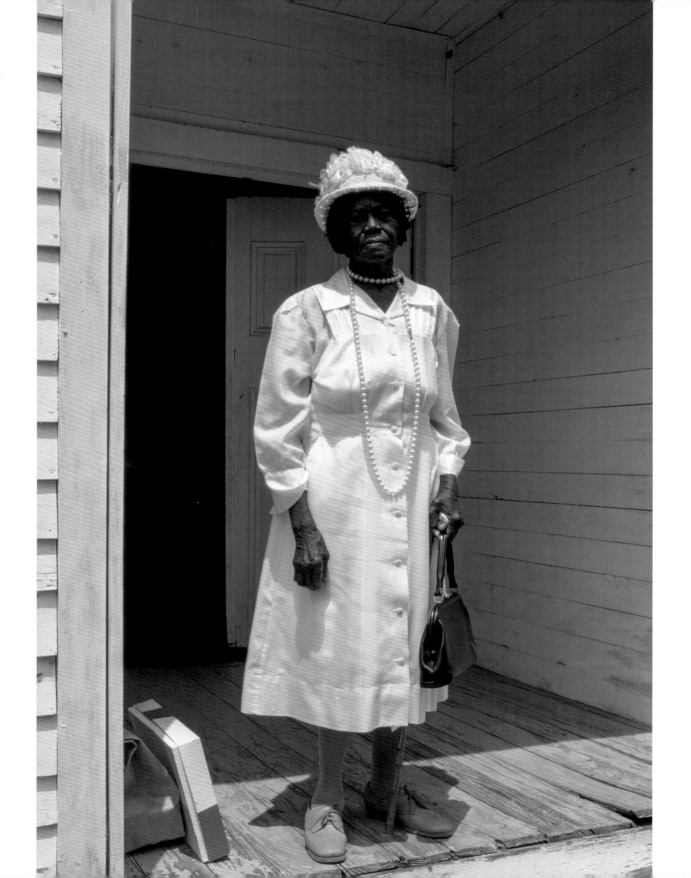

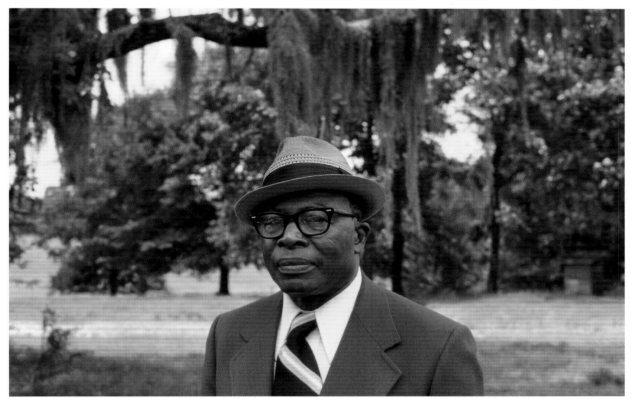

Reverend Isaac Thomas, Rose Hill Church, Fisher Ferry Road, Warren County, Mississippi, 1975

Amanda Gordon, Rose Hill Church, Fisher Ferry
Road, Warren County, Mississippi, 1975

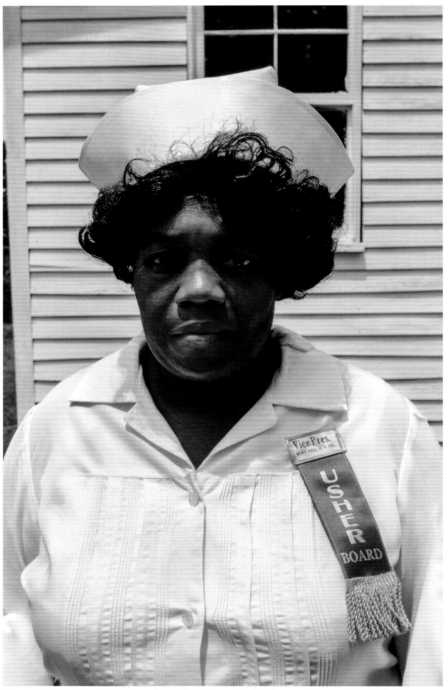

Rosa Wallace, Rose Hill Church, Fisher Ferry Road, Warren County, Mississippi, 1975

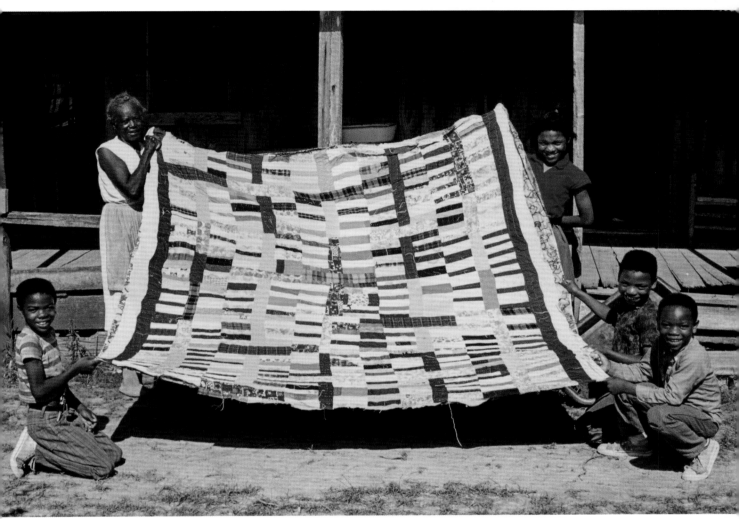

Top left, clockwise: Amanda Gordon, Diane Wright Smith, Shelby Wright, Sammy Wright, and John Henry Wright, home of Amanda Gordon, 10536 Fisher Ferry Road, Warren County, Mississippi, 1975

19

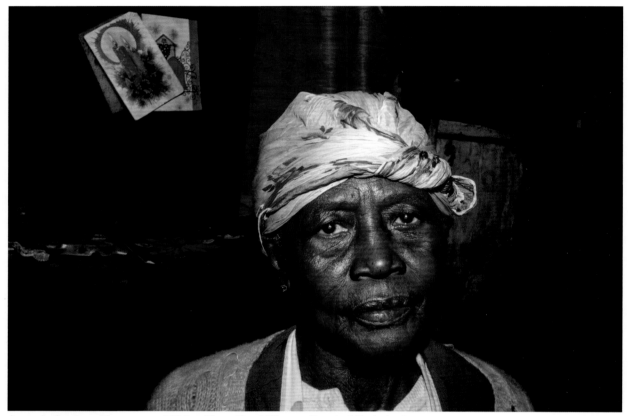

Amanda Gordon at home, 10536 Fisher Ferry Road, Warren County, Mississippi, 1975

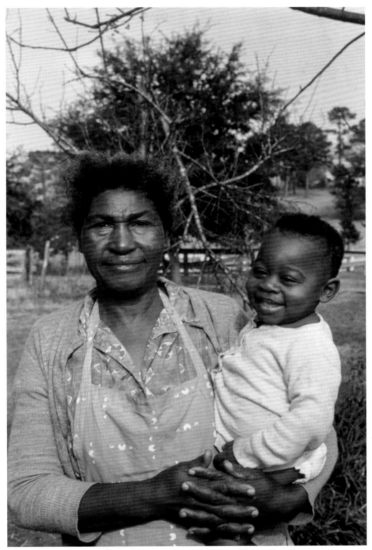

Eliza Price and Eddie McGowan, 11188 Fisher Ferry Road,
Warren County, Mississippi, 1963

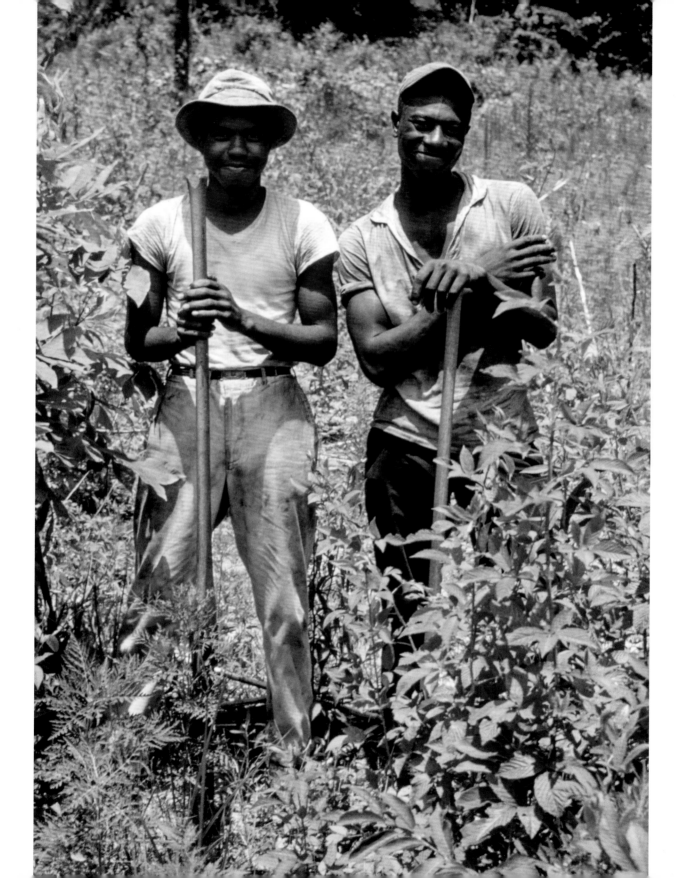

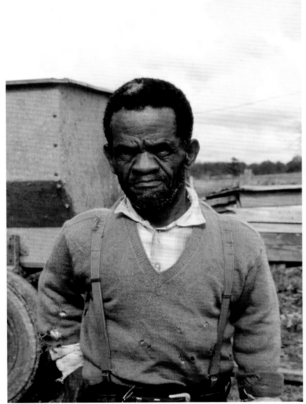

Robert Appleton, Fisher Ferry Road, Warren County, Mississippi, 1963

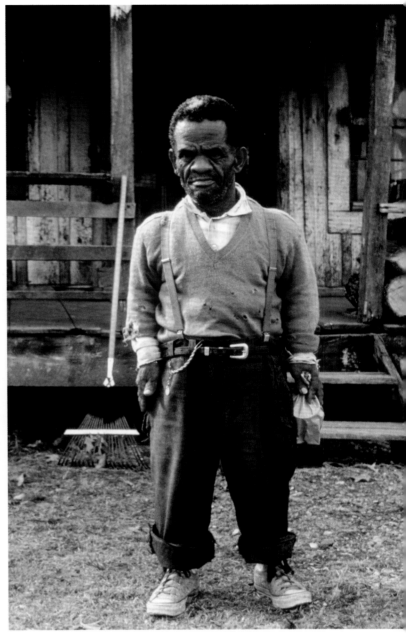

Robert Appleton, Fisher Ferry Road, Warren County, Mississippi, 1963

William Appleton and George Martin, Fisher Ferry Road, Warren County, Mississippi, 1963

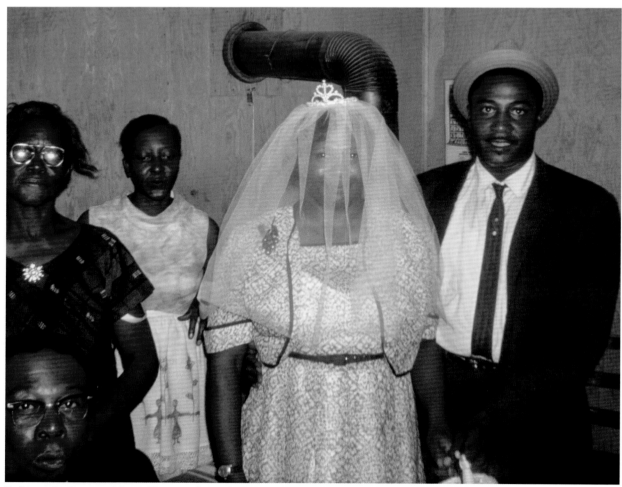

Left to right: Reverend Isaac Thomas, Amanda Gordon, Fanny Dunbar, Artemese and Jesse Cooper, 11293 Fisher Ferry Road, home of Artemese and Jesse Cooper, Warren County, Mississippi, 1963

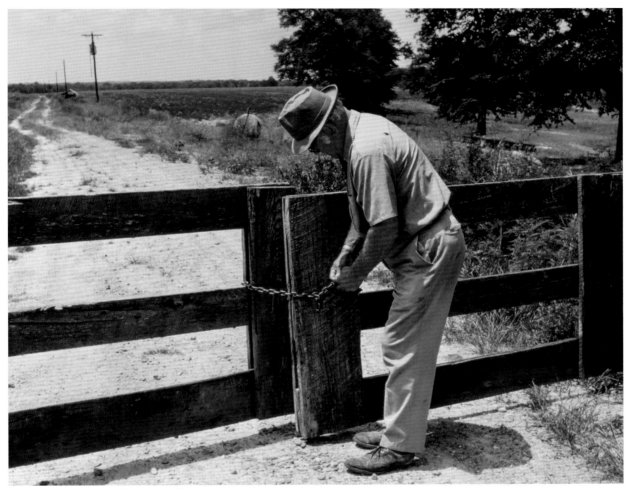

William Ferris Sr., Carlisle Road, Warren County, Mississippi, 1963

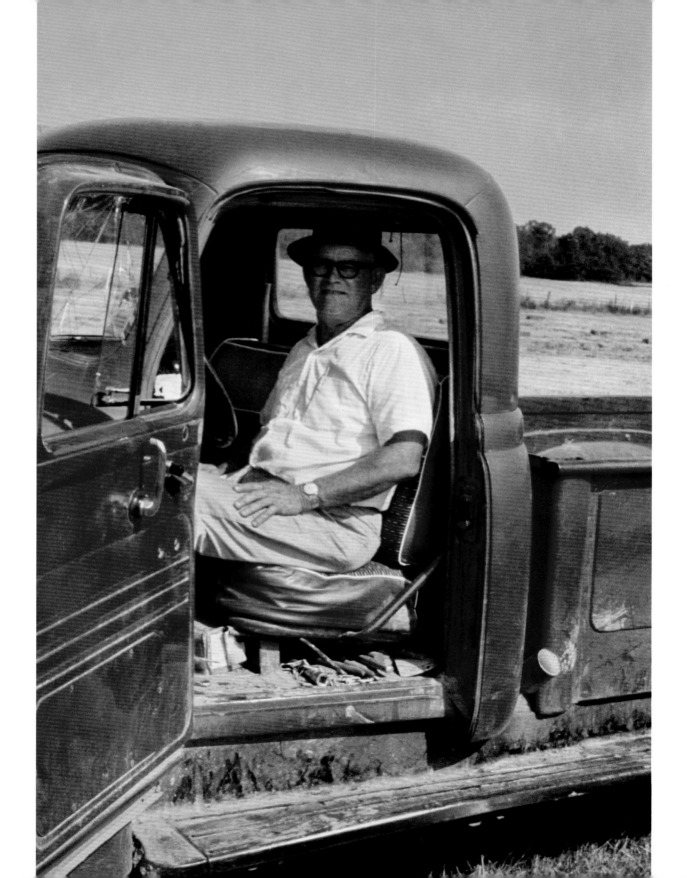

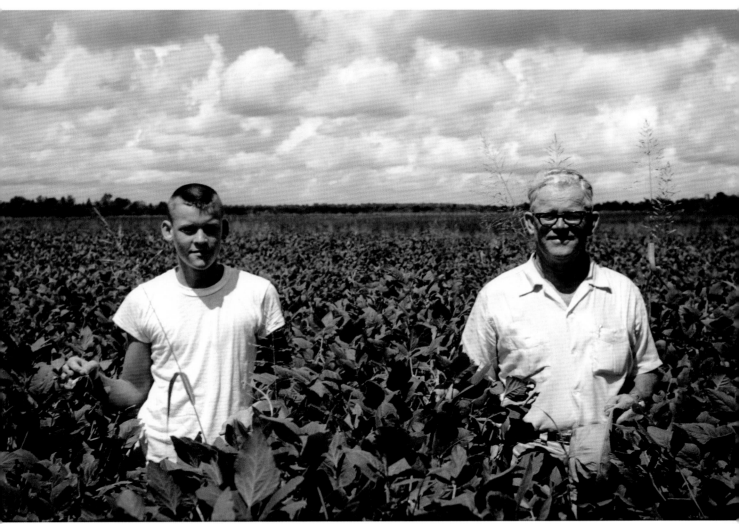

Grey Ferris and William Ferris Sr., soybean field, Warren County, Mississippi, 1963

William Ferris Sr., hay field, Fisher Ferry Road, Warren County, Mississippi, 1963

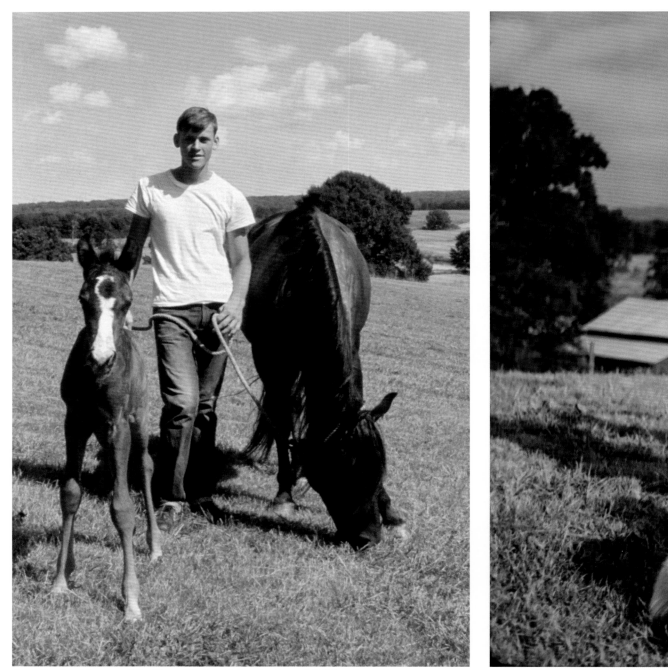

Grey Ferris with mare (War Trace Black Julie) and colt, 11186 Fisher Ferry Road,
Ferris home, Warren County, Mississippi, 1963

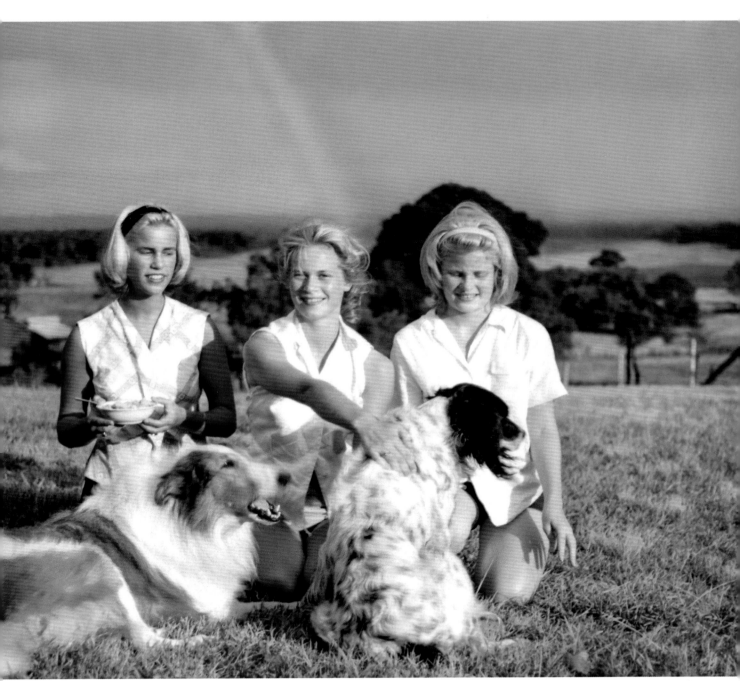

Left to right: Shelby Fitzpatrick, Hester Magnuson, Martha Ferris, King, and Queenie, 11186 Fisher Ferry Road, Ferris home, Warren County, Mississippi, 1963

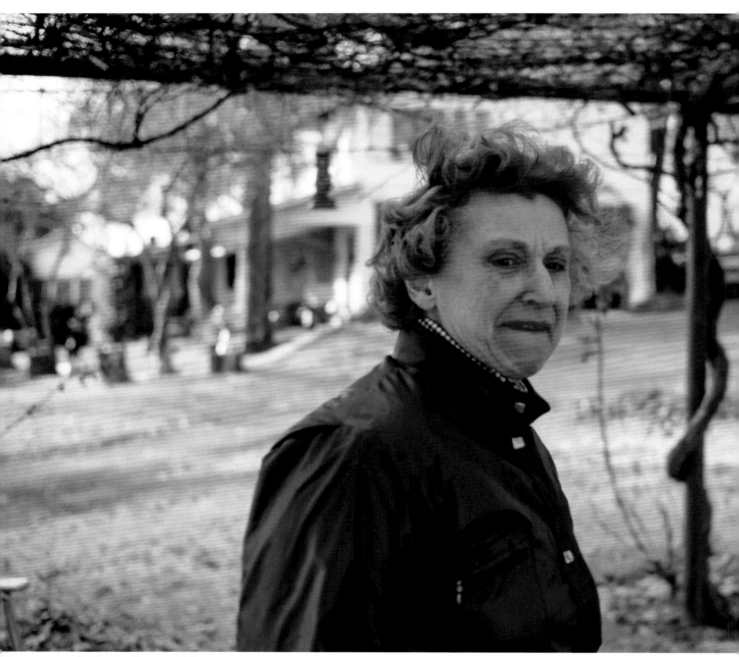

Shelby Ferris, 11186 Fisher Ferry Road, Ferris home, Warren County, Mississippi, 1975

30

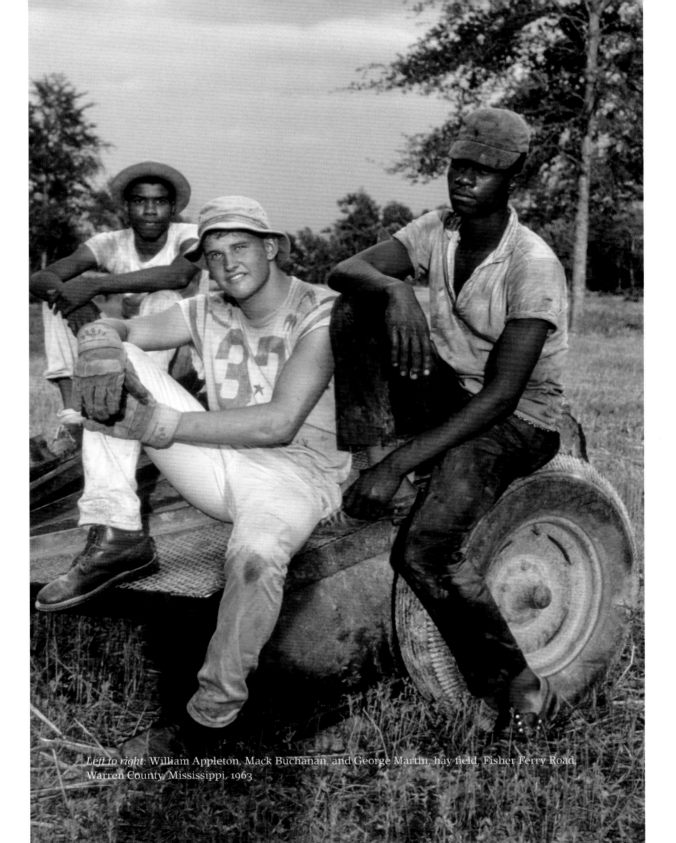

Left to right: William Appleton, Mack Buchanan, and George Martin, hay field, Fisher Ferry Road, Warren County, Mississippi, 1963

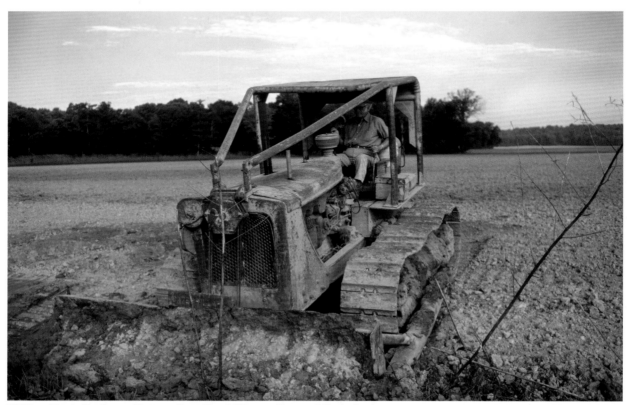

William Ferris Sr., James Bottom, Ross Road, Warren County, Mississippi, 1975

James Bottom, Ross Road, Warren County, Mississippi, 1975

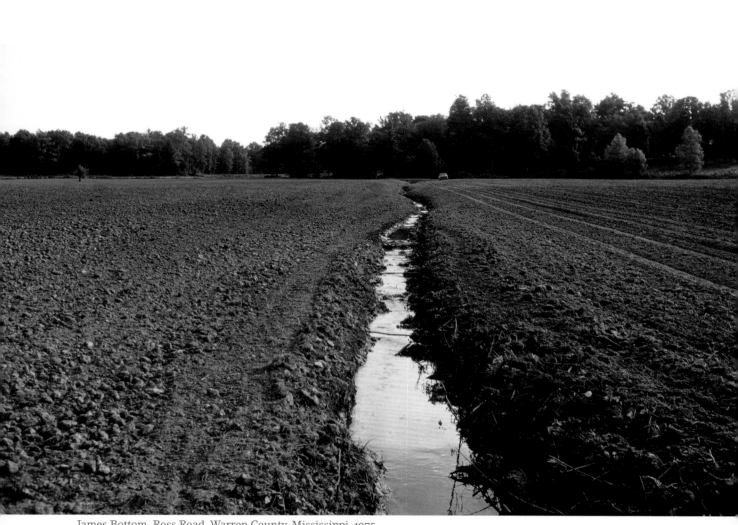

James Bottom, Ross Road, Warren County, Mississippi, 1975

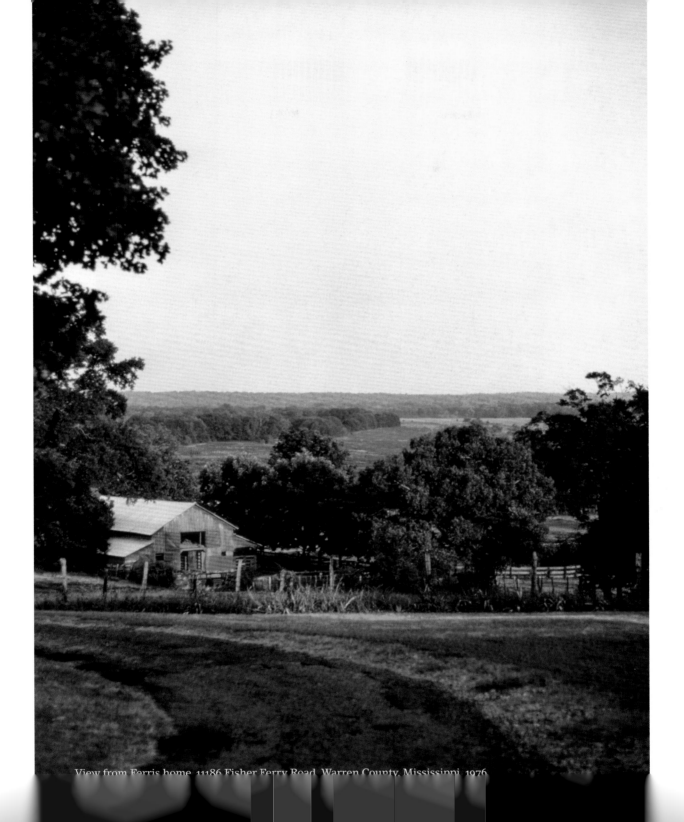

View from Ferris home, 11186 Fisher Ferry Road, Warren County, Mississippi, 1976

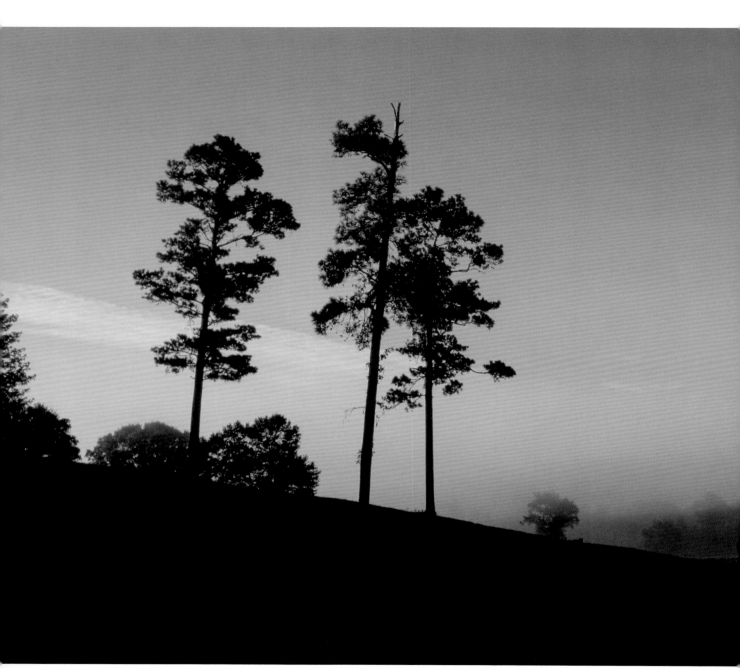

Rose Hill Church pasture, Fisher Ferry Road, Warren County, Mississippi, 1976

Horse pasture, Fisher Ferry Road, Warren County, Mississippi, 1976

Crepe myrtle tree in drive to Ferris home, 11186 Fisher Ferry Road, Warren County, Mississippi, 1976

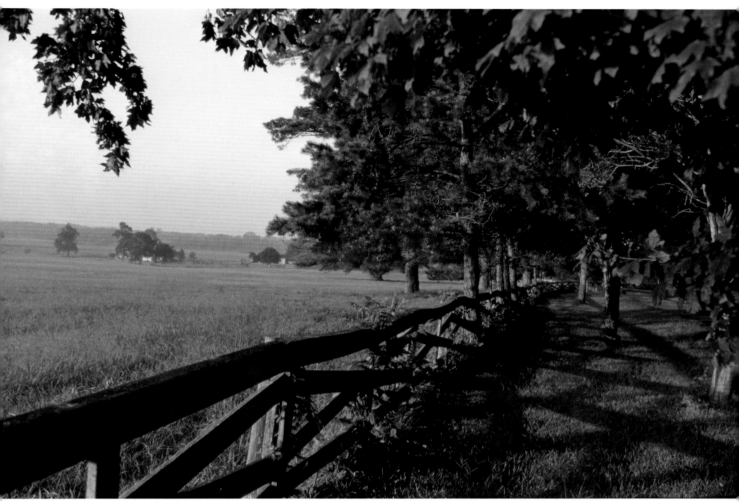

Horse pasture, Fisher Ferry Road, Warren County, Mississippi, 1975

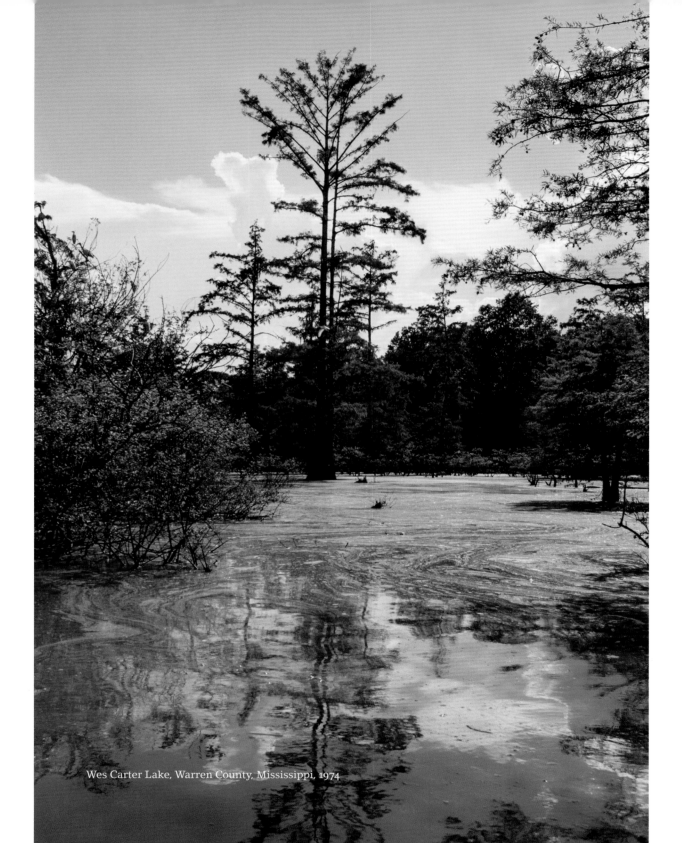

Wes Carter Lake, Warren County, Mississippi, 1974

PORTRAITS

These photographs are of individuals at work, at home, and at church. I love to photograph faces and hands with tight, close-up images that reveal the expression of intimate contact. These pictures capture each person with an intimacy that Alex Haley felt when he described the "elderly ladies, their hands deeply wrinkled from decades of quilting, canning, washing collective tons of clothing in black cast-iron pots.... These southern ancestors, black and white, have always struck me as the Foundation Timbers of our South."

These portraits are not of the region's celebrities—such as Eudora Welty and B.B. King—whom I photographed and wrote about elsewhere. They are, rather, prison inmates, quilt makers, and roadside vendors, photographed as they go about their daily lives. Each person has a deep connection to the place in which she or he lives, and they share intimate ties to family and friends in those places.

In that moment shared between the photographer and the person photographed, my camera enters intimate, personal space, looks into the eyes of the other person, and captures their soul. It is a moment in which the other person reveals their inner self to the eye of the camera, and their expression contains a special beauty.

These portraits address the character of each person. Their faces, their eyes, their lips create an intense, intimate expression. Their look is both welcoming and wary, a mix of comfort and unease with the camera and with me. It is a feeling that I understand and expect as a photographer. My camera captures that brief moment when the photographer and the person photographed connect as I enter their intimate space and preserve it with my camera.

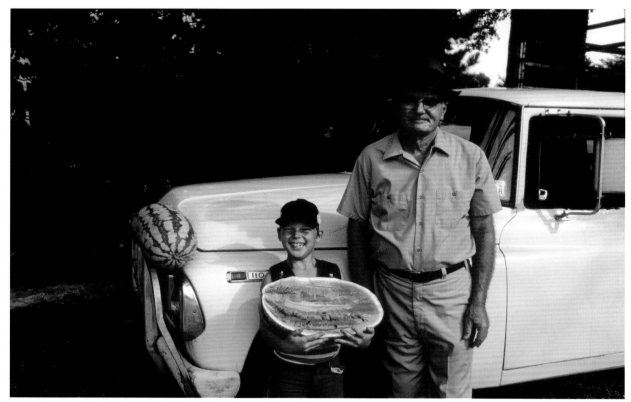

Unidentified watermelon vendor and son, Betcheimer Store, Highway 27, Utica, Mississippi, 1974

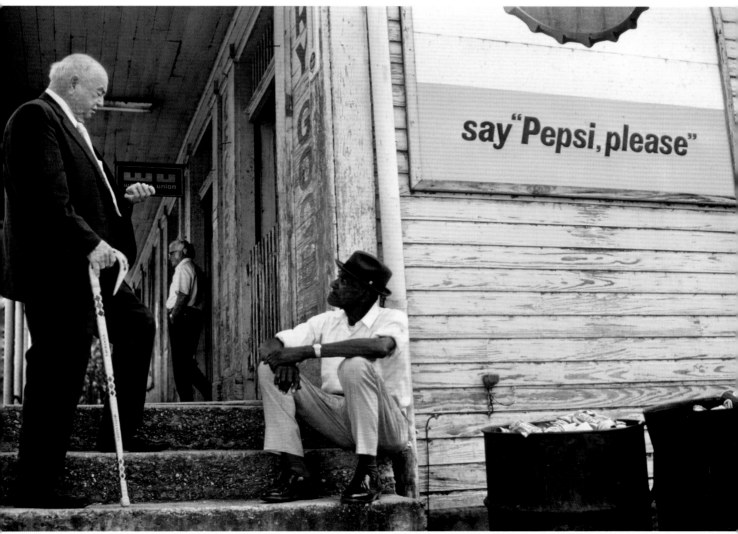

Left to right: Ray Lum, William Ferris Sr., unidentified man, Cohn Brothers Country Store, Lorman, Mississippi, circa 1975

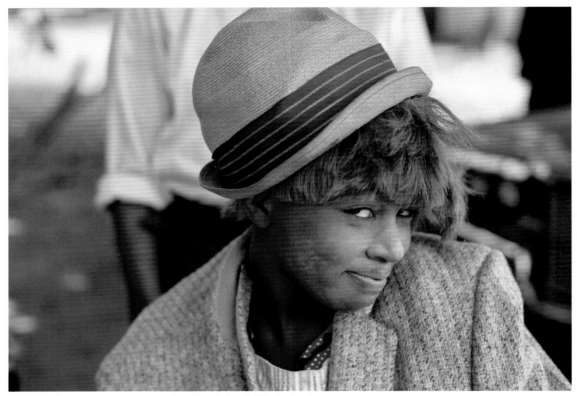

Unidentified street actress, Kent's Alley, Leland, Mississippi, 1974

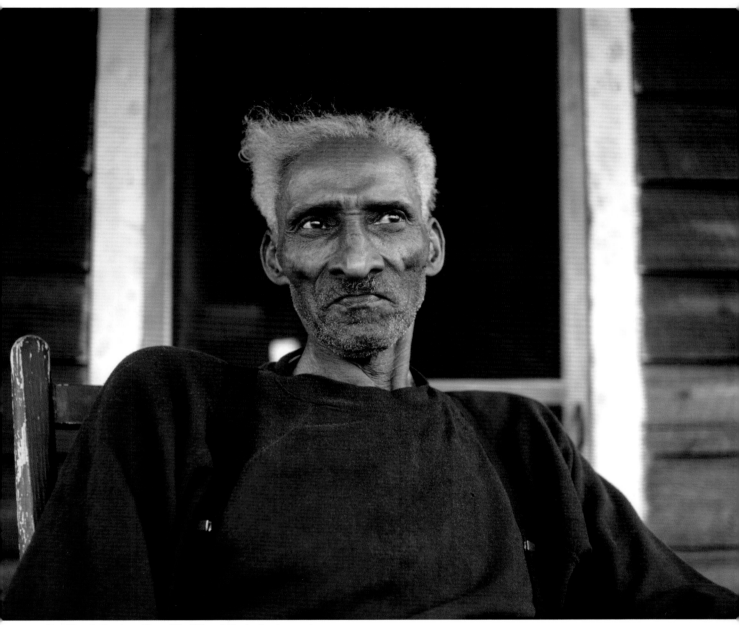

Jim Steed, Route 1, Box 18A, Utica, Mississippi, 1974

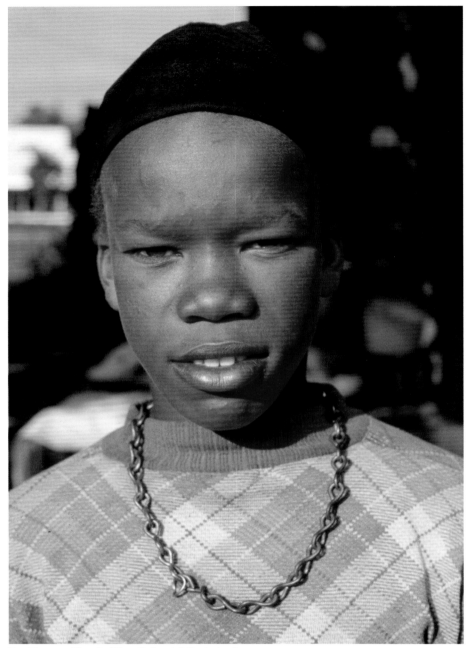

Pat Thomas, Kent's Alley, Leland, Mississippi, 1974

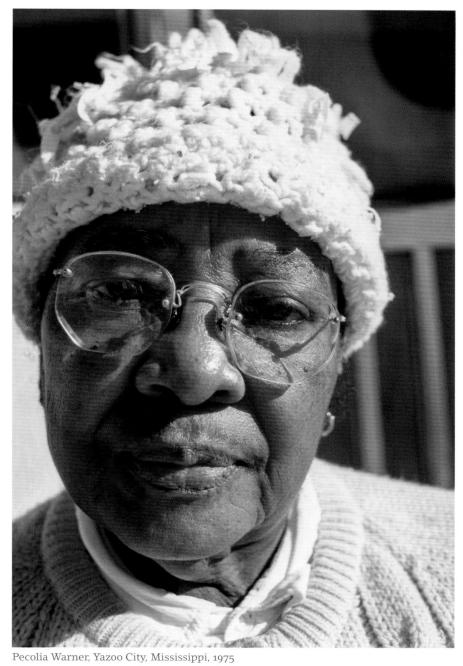

Pecolia Warner, Yazoo City, Mississippi, 1975

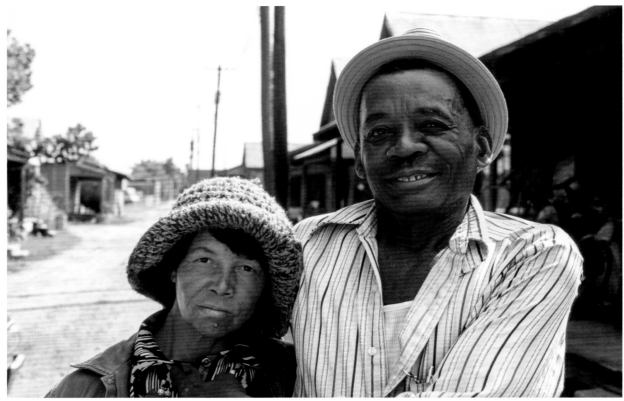

Left to right: Leola Frye and Shelby "Poppa Jazz" Brown, Kent's Alley, Leland, Mississippi, 1974

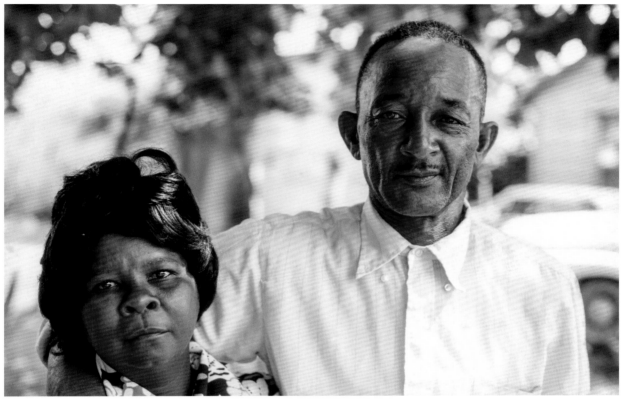

Left to right: Lee Cooper and Joe Cooper, Kent's Alley, Leland, Mississippi, 1974

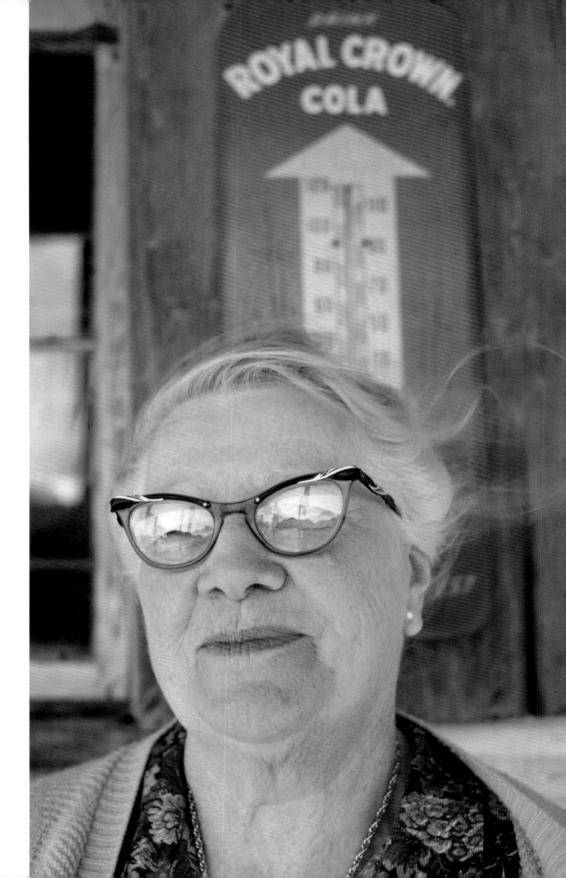

Aden Fisher White,
S. M. White & Son
Crossroads Store,
Old Port Gibson
Road, Reganton,
Mississippi, 1974

50

Leon "Peck" Clark,
Sharon, Mississippi, 1974

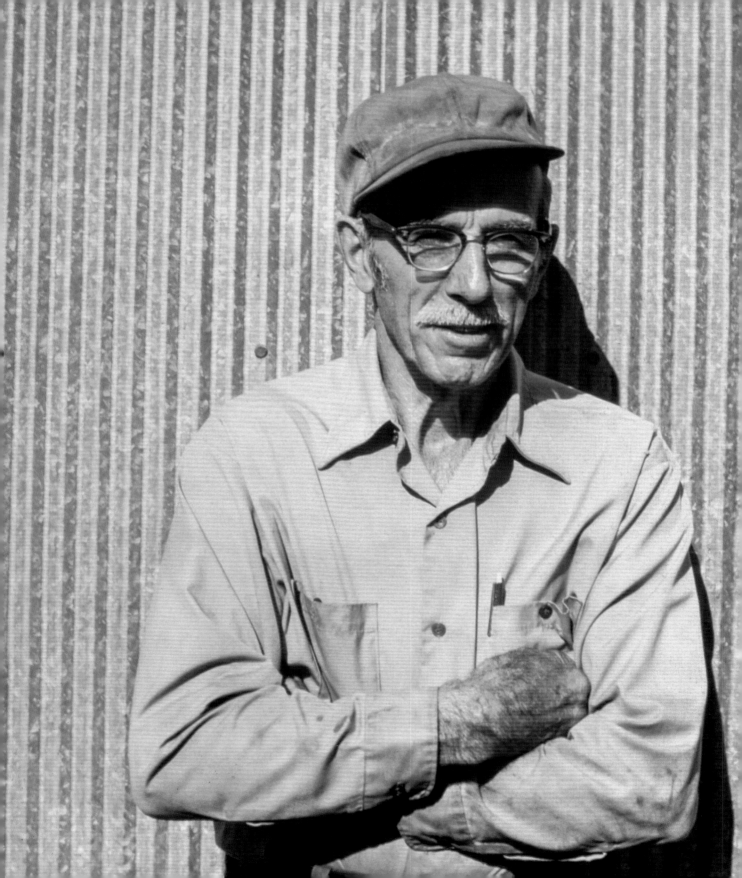

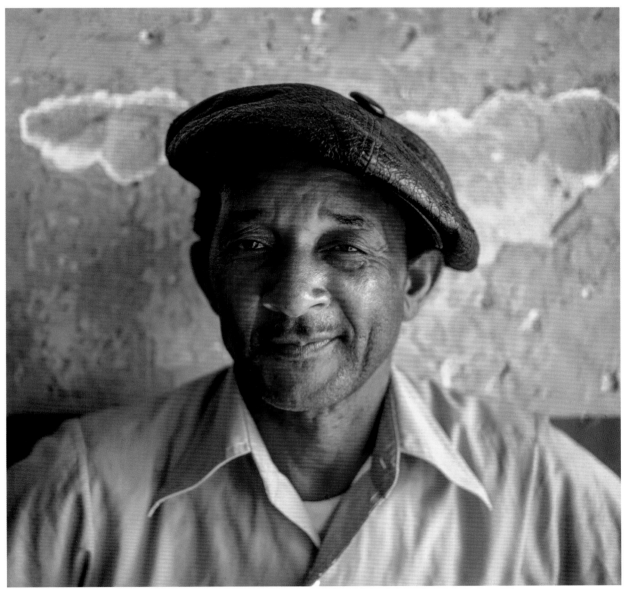

Joe Cooper, Leland, Mississippi, 1976

Cecil Crosby, Fisher Ferry Road, Warren County, Mississippi, 1974

Unidentified man and woman, Cohn Brothers Country Store, Lorman, Mississippi, 1974

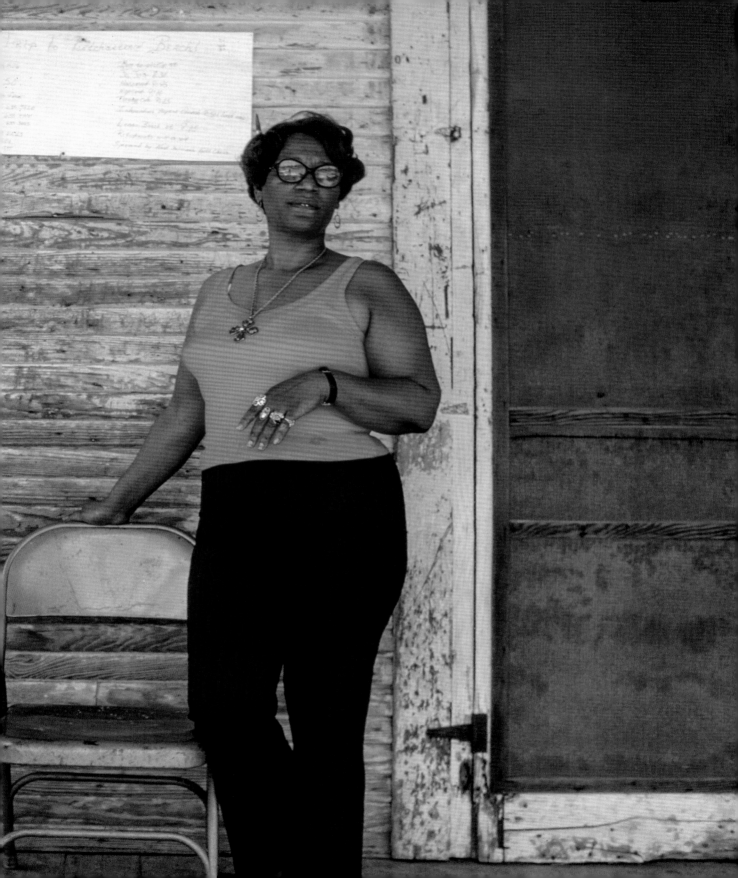

Victor "Hickory Stick" Bobb, Vicksburg, Mississippi, June 1976

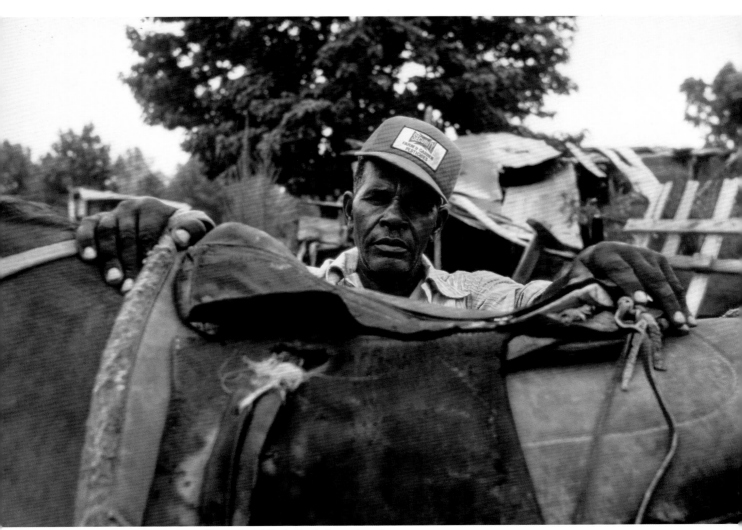

Otha Turner, Route 1, Box 296, Senatobia, Mississippi, August 1976

Louvennia Willis and Nora (a neighbor's child),
Route 1, Box 86, Crystal Springs, Mississippi, 1974

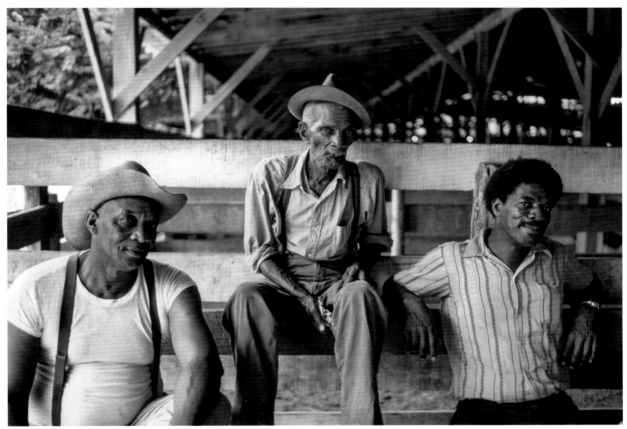

Unidentified men, Lum Auction Barn, Vicksburg, Mississippi, August 1976

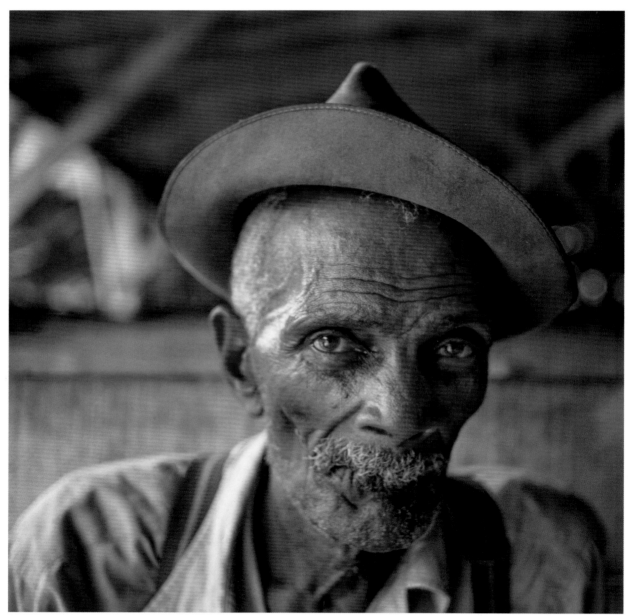

Unidentified man, Lum Auction Barn, Vicksburg, Mississippi, August 1976

Edith Clark, Old Port Gibson Road, Reganton, Mississippi, summer 1976

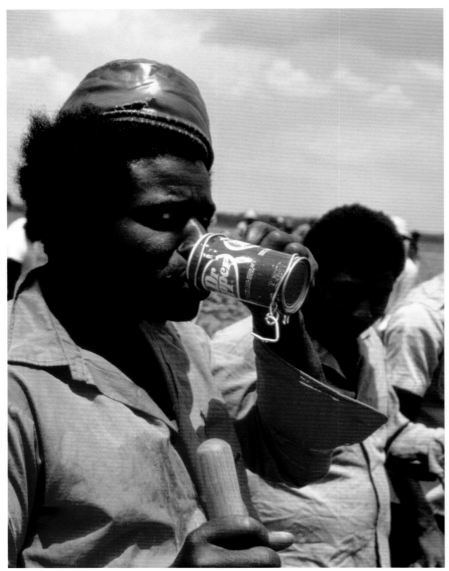

Inmate on water break, Parchman Penitentiary, Camp B, Lambert, Mississippi, 1974

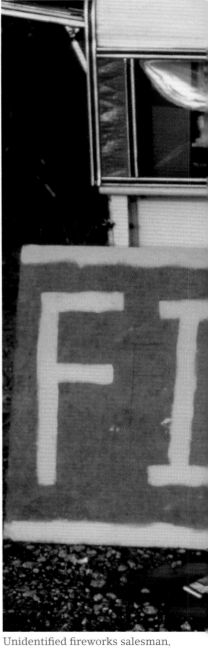

Unidentified fireworks salesman, Leland, Mississippi, circa 1976

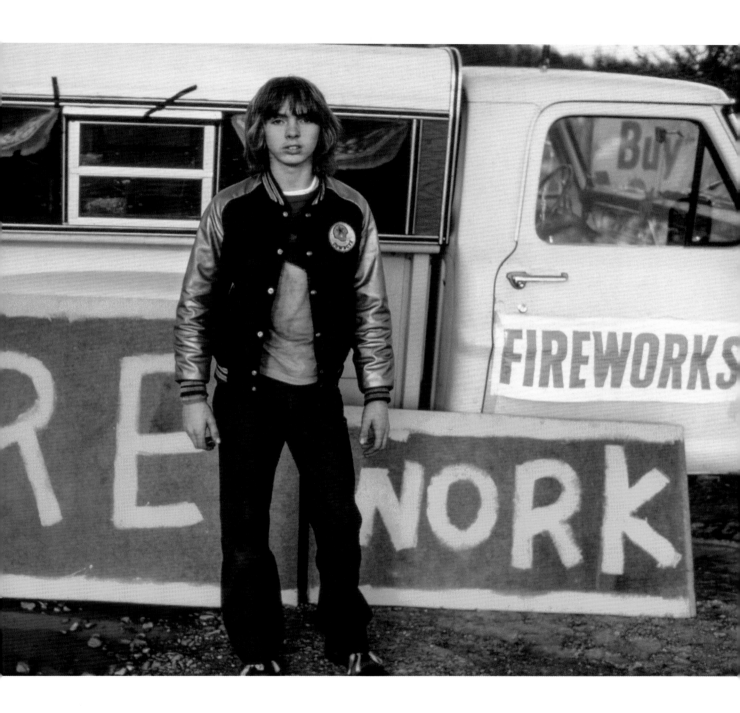

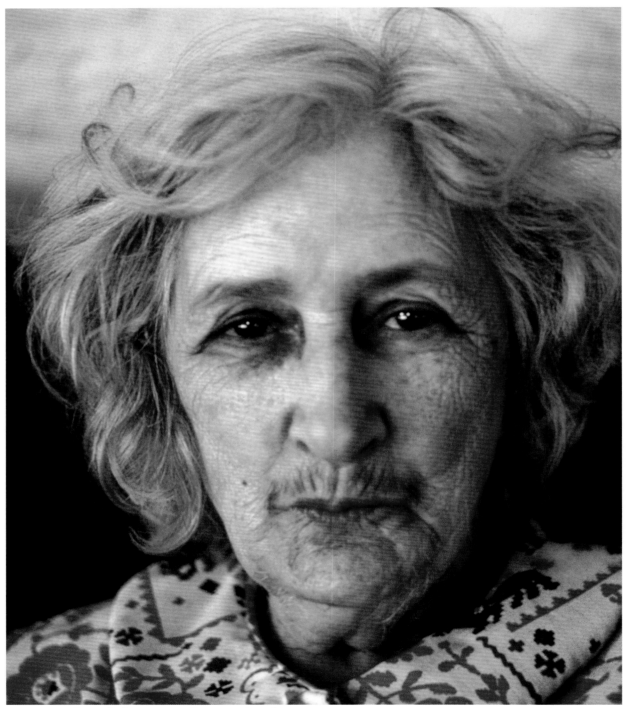

Mary Regan, "Vernalia," Reganton, Mississippi, March 1977

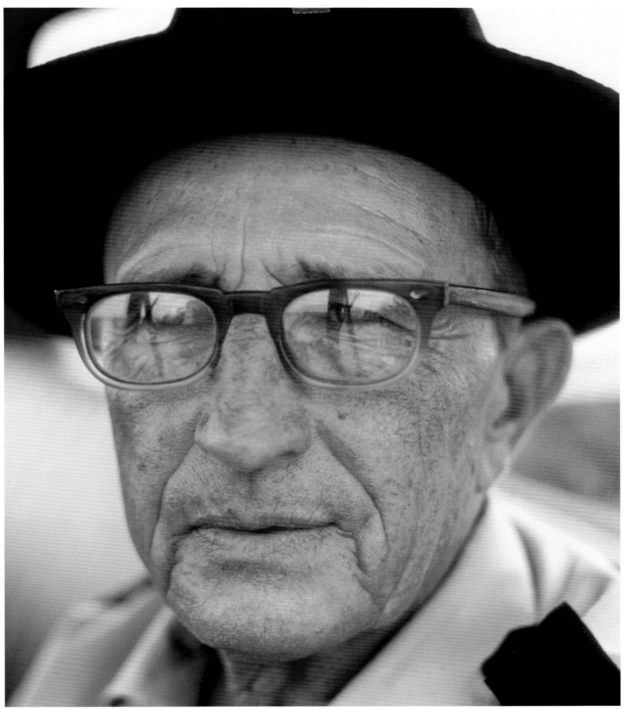

Sergeant Webb, Parchman Penitentiary, Camp B, Lambert, Mississippi, 1974

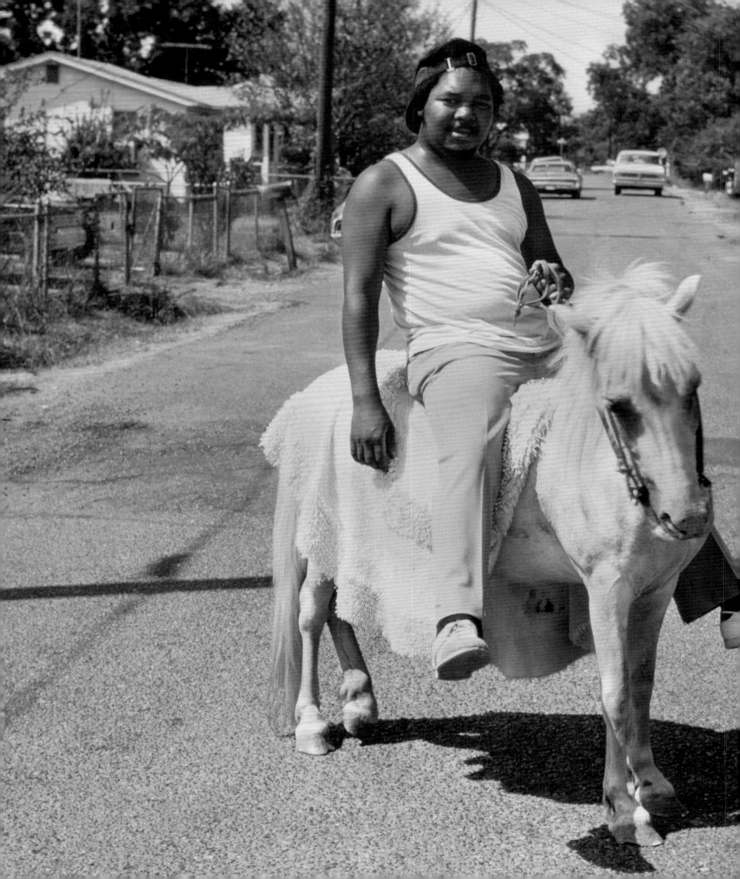

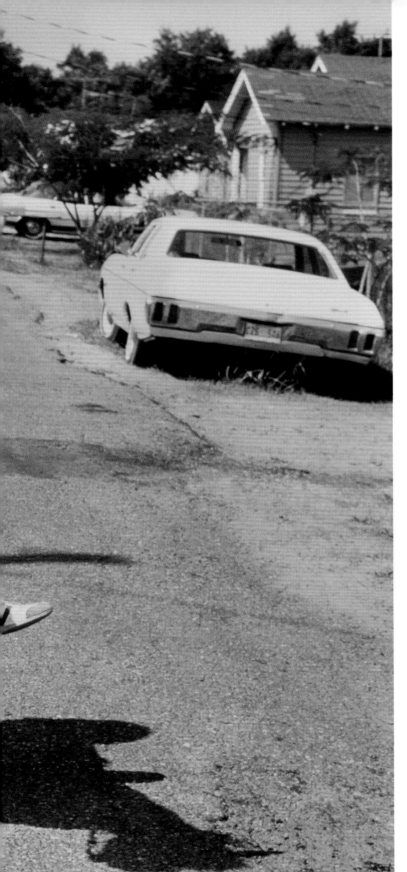

Unidentified rider and pony, Yazoo City, Mississippi, 1975

67

Unidentified
teenagers,
Leland,
Mississippi,
1974

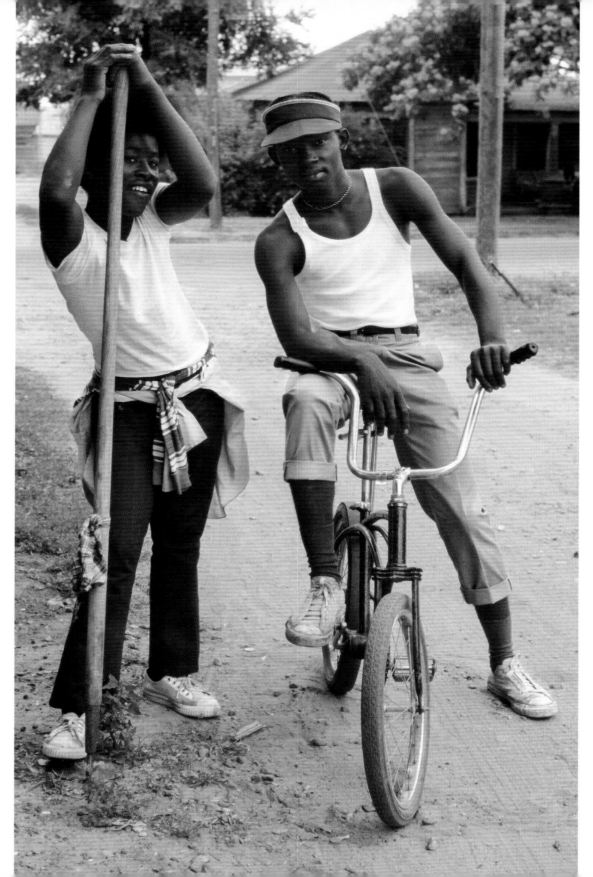

BUILDINGS

Homes, churches, and blues clubs define sacred and secular worlds that are intimately linked to the people who inhabit them. The weathered wood siding of the buildings has endured the seasons of many years. These iconic structures mark their profiles against the landscape and sky, and they define a place and its people in profound ways.

Rose Hill Church is a sacred space that embraced and nurtured generations of families from birth to death. Houses and the walls within them define the families who live there. Family photographs of spouses, children, and ancestors animate rooms and attest to how these images preserve family memories.

Blues clubs celebrate the power of music with vivid signs that announce upcoming concerts and sternly warn against violence and inappropriate language. The blues club and the church are secular and sacred spaces that touch the hearts of people who visit them each week. On Saturday night, people party in the club, and on Sunday morning they worship in the church.

Buildings—like the people who occupy them—are a familiar, enduring presence in each community. They claim their place and define their surroundings with authority.

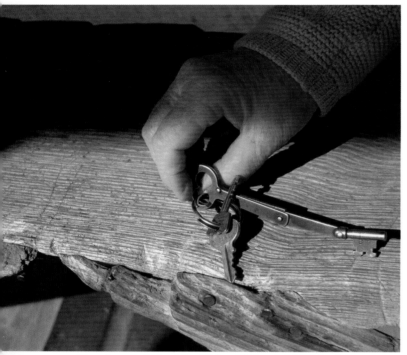

Store keys held by Aden Fisher White, S. M. White & Son
Crossroads Store, Old Port Gibson Road, Reganton,
Mississippi, 1974

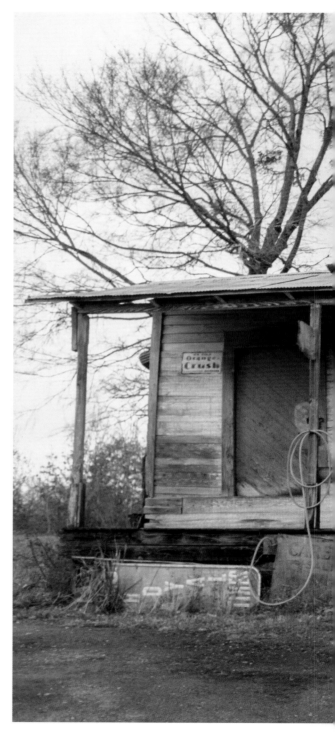

S. M. White & Son Crossroads Store, Old Port
Gibson Road, Reganton, Mississippi, 1974

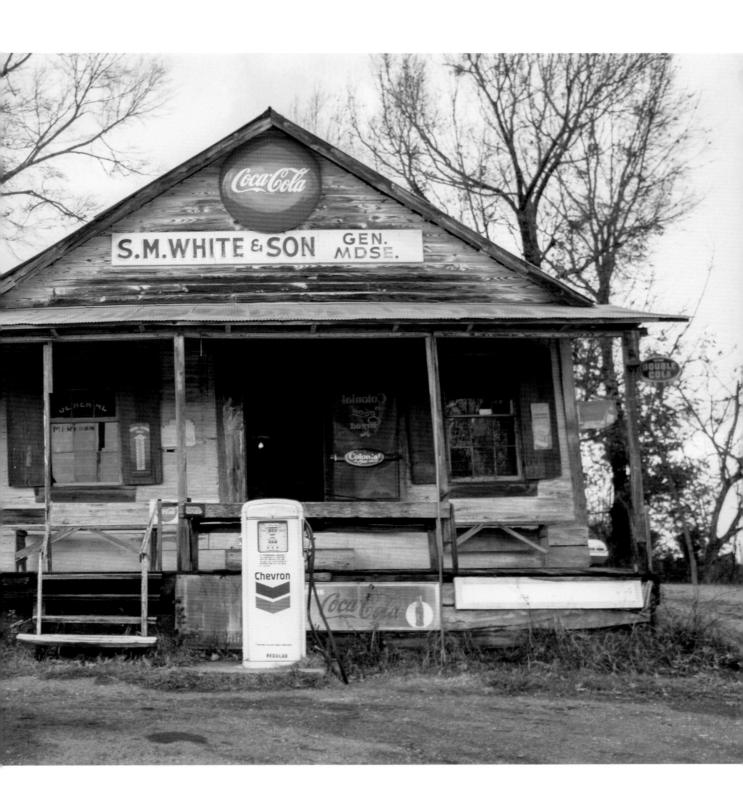

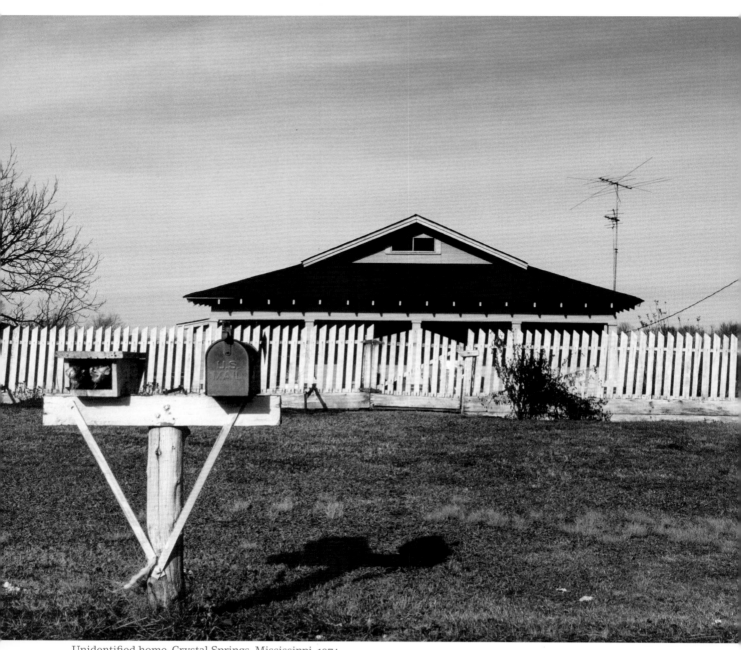

Unidentified home, Crystal Springs, Mississippi, 1974

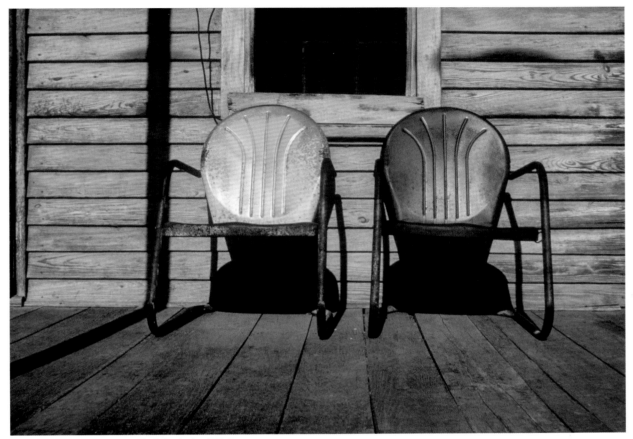

Metal chairs on front porch, Mississippi Delta, 1975

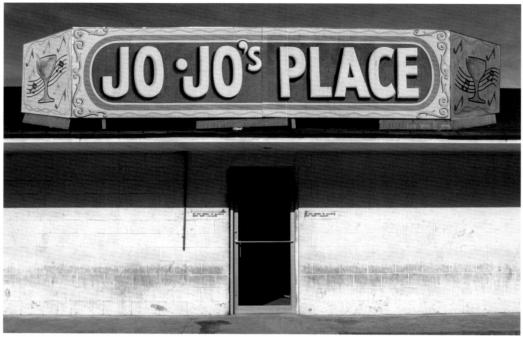

Jo Jo's Place, Crystal Springs, Mississippi, 1975

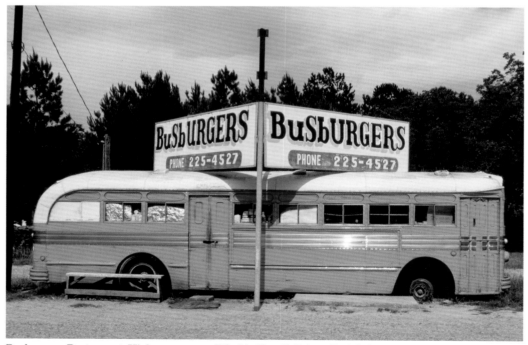

Busburgers Restaurant, Highway 19 near Ethel in East Feliciana Parish, Louisiana, June 1976

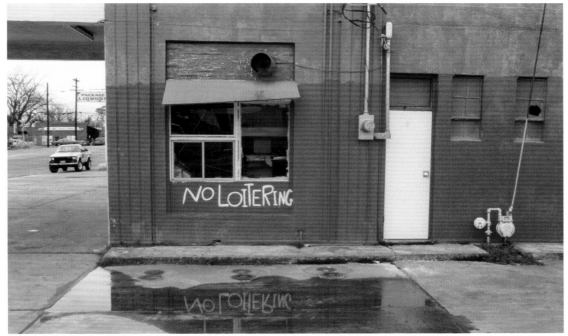

No Loitering sign, Mississippi Delta, 1975

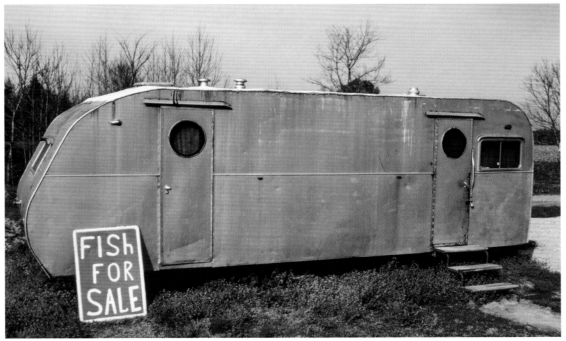

Roadside trailer, Highway 61, north of Vicksburg, Mississippi, March 1977

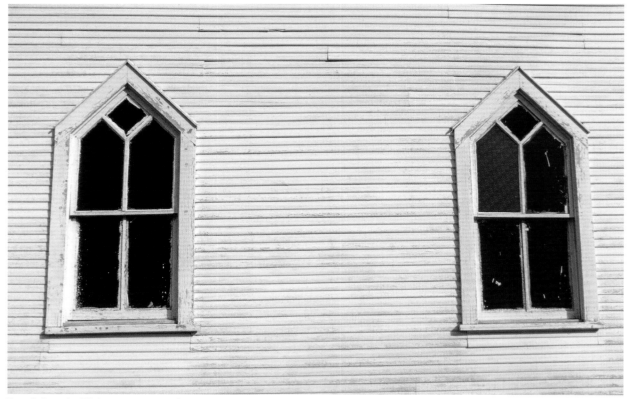

Rural church, Highway 27, west of Vicksburg, Mississippi, March 1977

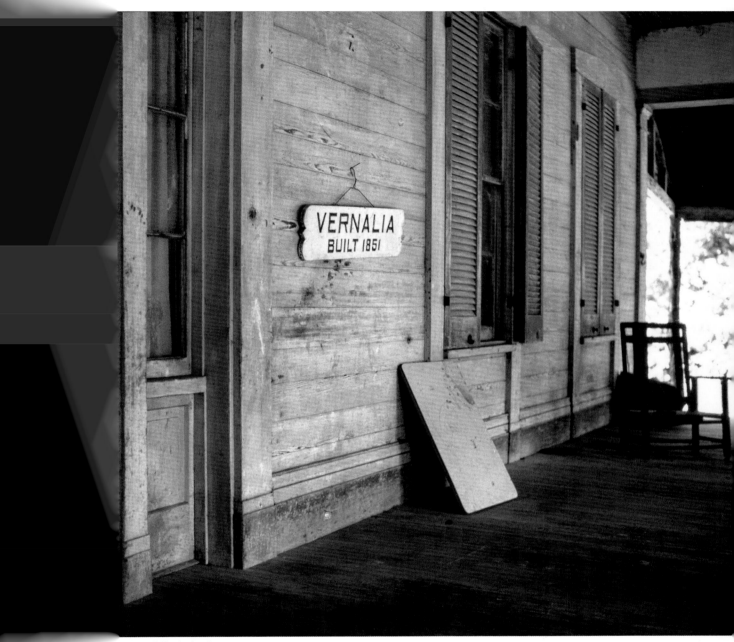

anton, Mississippi, 1979

AIR-COOLED!
CRESCENT THE
TONIGHT — First run Pictu

Crescent Theatre, 211 North Hayden Street,
Belzoni, Mississippi, 1977

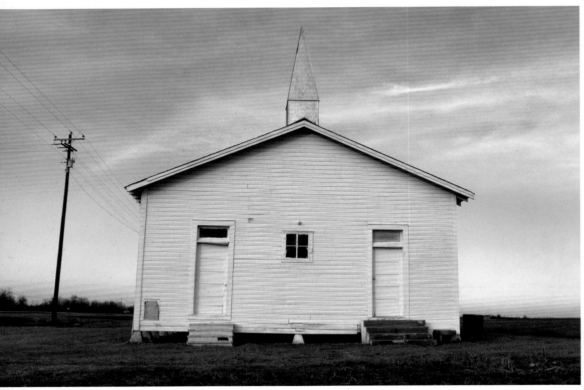

Rural church, Mississippi Delta, 1976

Clover Valley M. B. Church, Vicksburg, Mississippi, June 1977

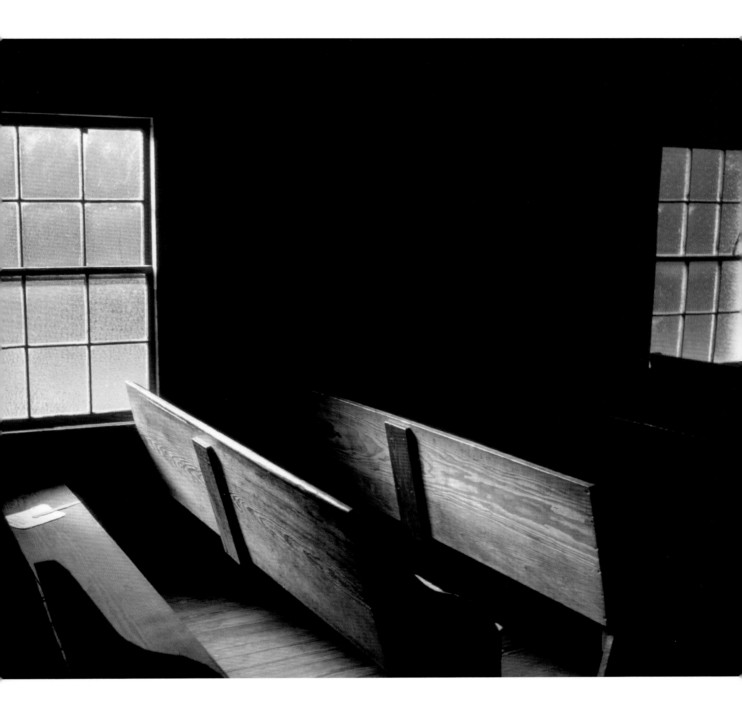

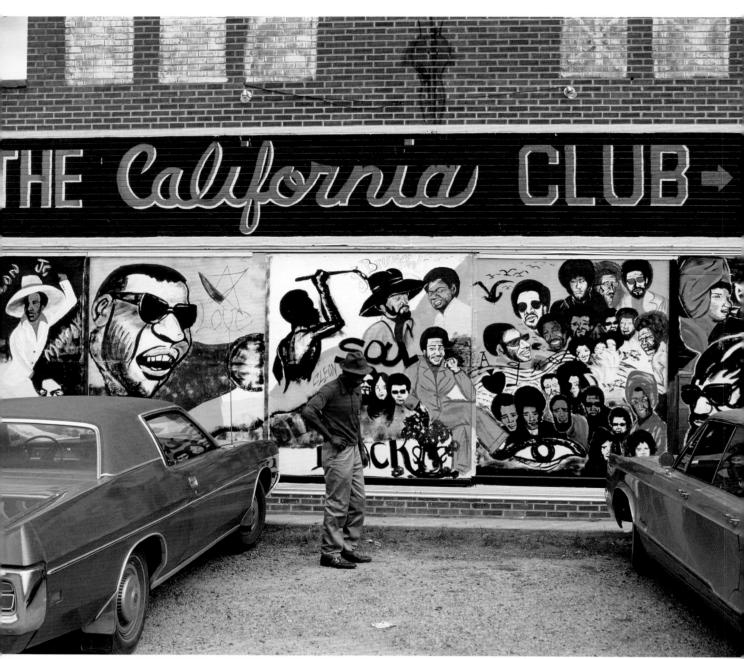

The California Club, 310 Silver City Road, Belzoni, Mississippi, August 1975

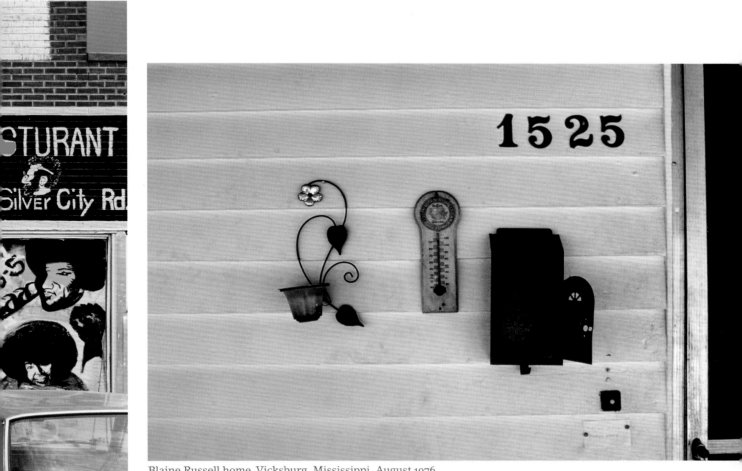

Blaine Russell home, Vicksburg, Mississippi, August 1976

Parchman Penitentiary, Camp B, Lambert, Mississippi, 1974

HANDMADE COLOR

Handmade signs nailed to or painted on the walls and doors of homes, blues clubs, stores, and churches are how artists claim spaces with their color, language, and images. These signs provide a distinctive look to buildings and landscape in each community.

The written word becomes art as words flow in unexpected directions and create dynamic, rhythmic designs with phrases like "Get Right With God," "Fresh Fish—Gar and Gasper Goo," and "Duck Plucker." Handmade signs are a familiar, organic part of each community. They bond art and language in a spiritual way that relies heavily on vivid colors.

Paintings, sculpture, and quilts are extensions of their community as the artist's eye creates exciting designs that offer a fresh, surprising beauty. Local artists create a bold new world that, like faces and buildings, defines each community.

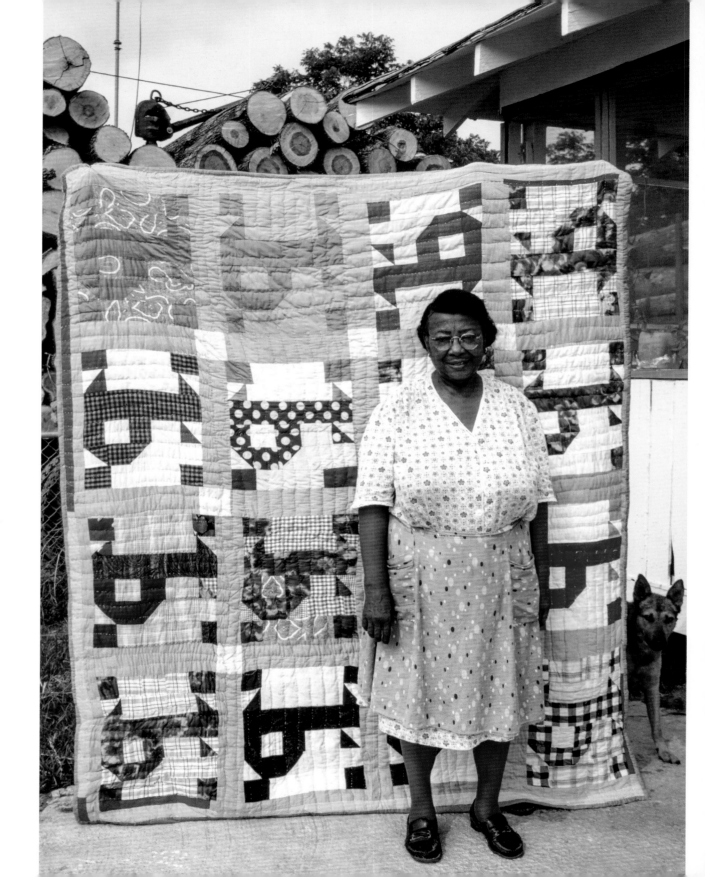

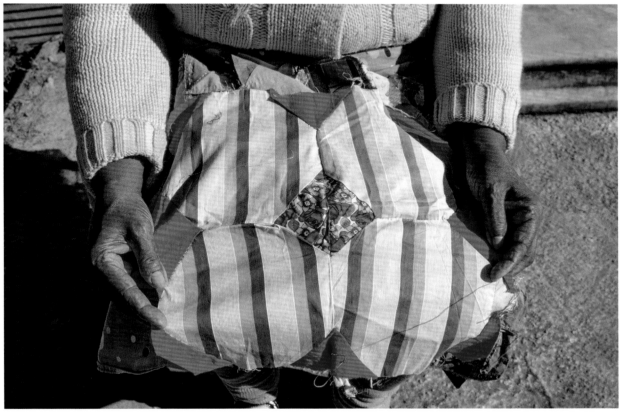

Pecolia Warner, Yazoo City, Mississippi, 1975

Pecolia Warner with her "P" quilt, Yazoo City, Mississippi, 1975 87

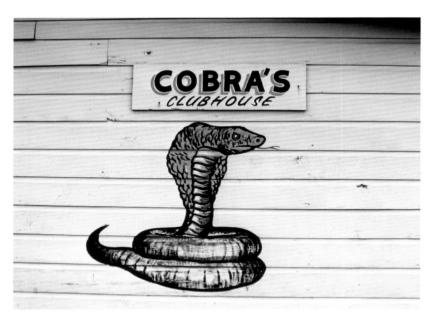

Cobra's Clubhouse, Belzoni, Mississippi, 1977

The California Club, 310 Silver City
Road, Belzoni, Mississippi, circa 1977

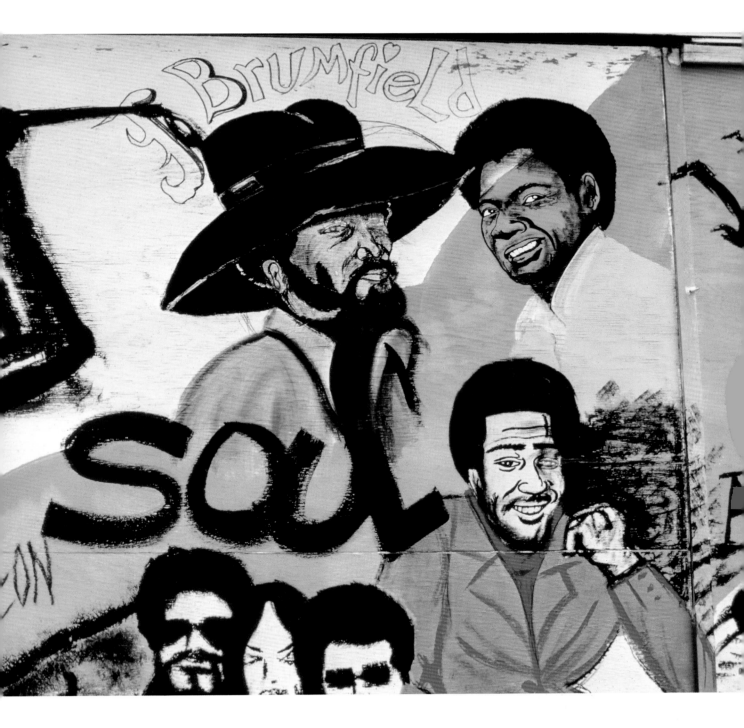

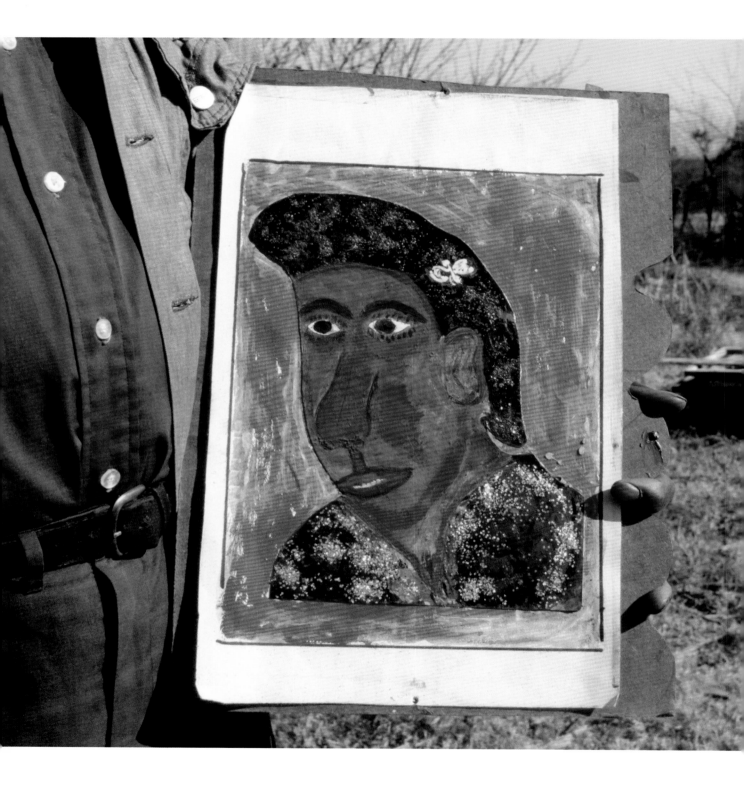

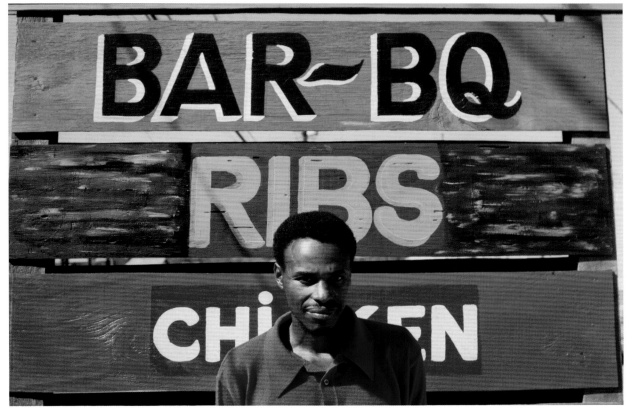

Harry Warren with signs he painted, Marcus Bottom, Vicksburg, Mississippi, March 1976

Luster Willis with oil and glitter portrait, Crystal Springs, Mississippi, December 1975

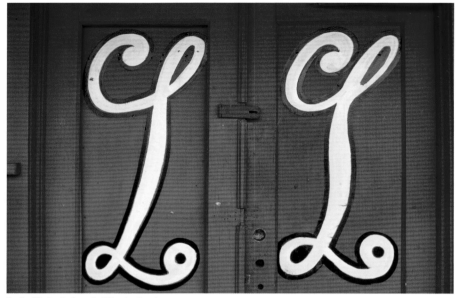

L. L. Club, Leland, Mississippi, 1975

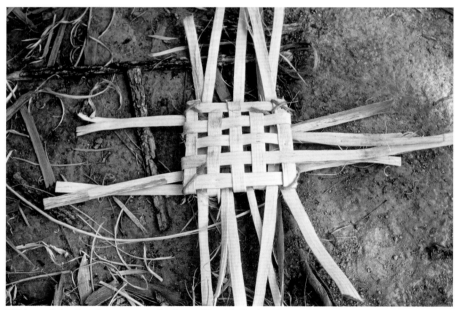

White oak basket frame made by Leon "Peck" Clark, Sharon, Mississippi, 1973

92

Hubert Hamblett portrait by Theora Hamblett, Oxford, Mississippi, August 1975

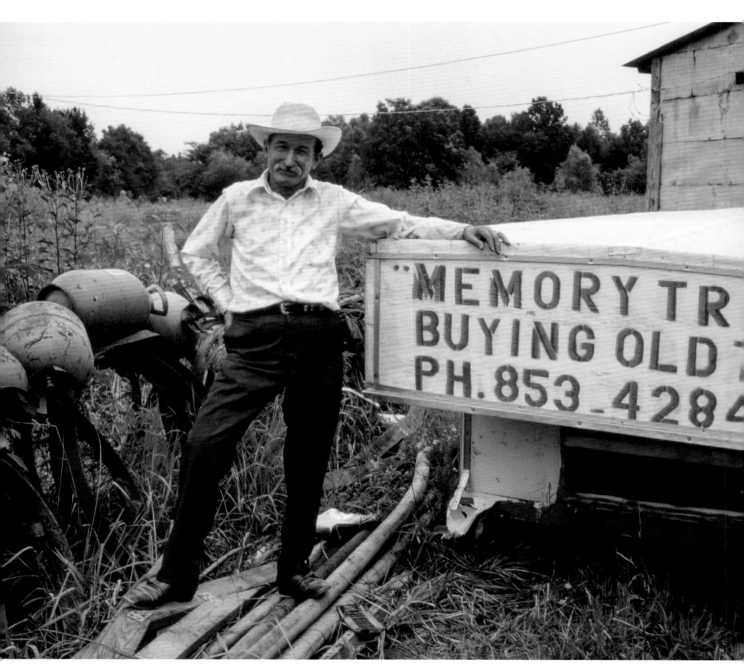

J. L. Garrison, Rossville, Tennessee, summer 1976

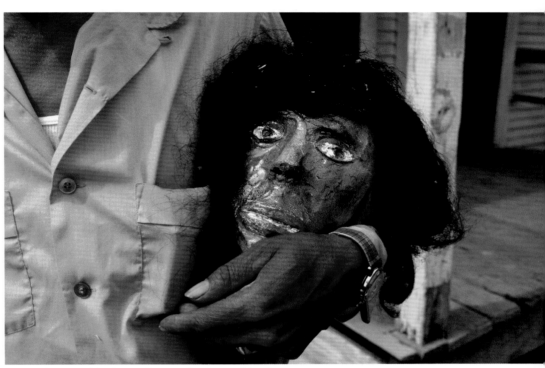

James Thomas with clay sculpture of woman with wig,
Leland, Mississippi, summer 1976

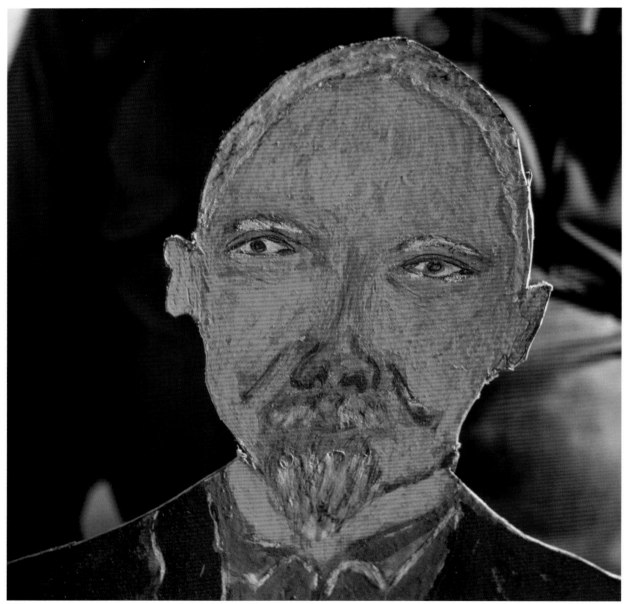

Wood and oil portrait by Luster Willis, Crystal Springs, Mississippi, 1976

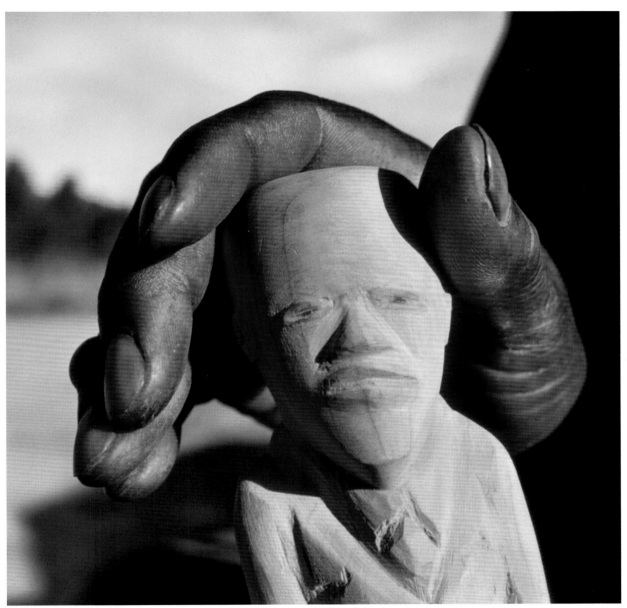

Head of cedar walking cane carved by Luster Willis, Crystal Springs, Mississippi, 1976

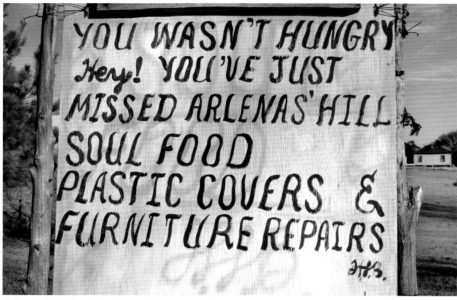

Arlena's Hill Soul Food sign, Highway 27, between Utica and Crystal Springs, Mississippi, January 1976

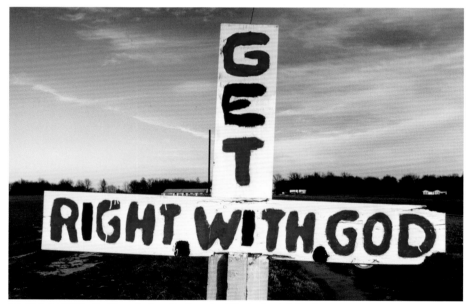

"Get Right With God" road sign, Indianola, Mississippi, March 1977

Painted door sign, Indianola, Mississippi, 1974

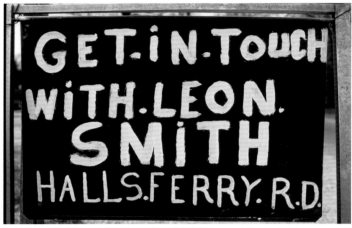

Leon Smith sign, Halls Ferry Road, Vicksburg, Mississippi, 1976

Jim Steed mailbox, Route 1, Box 18A,
Utica, Mississippi, 1974

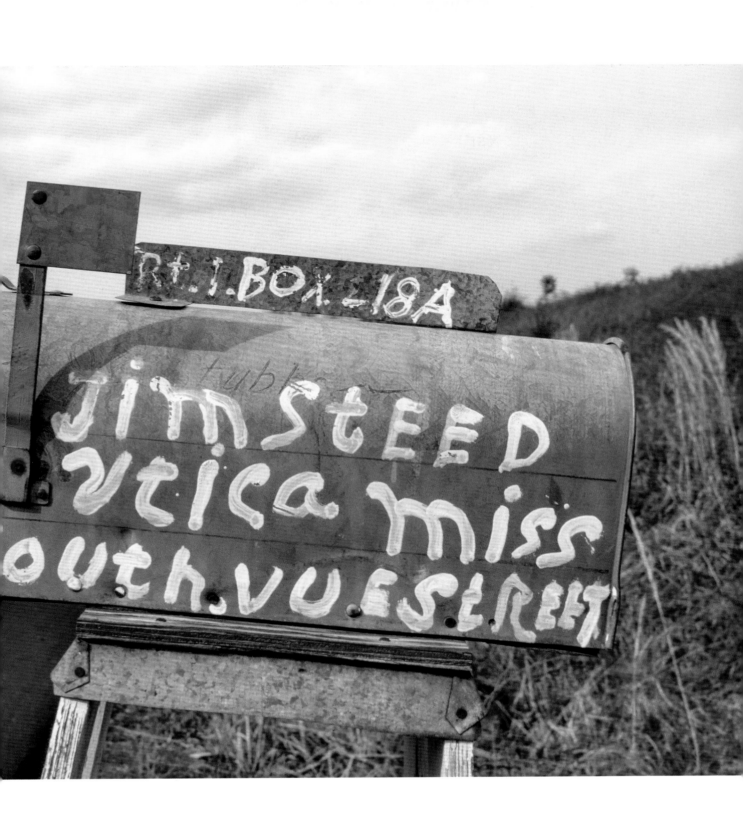

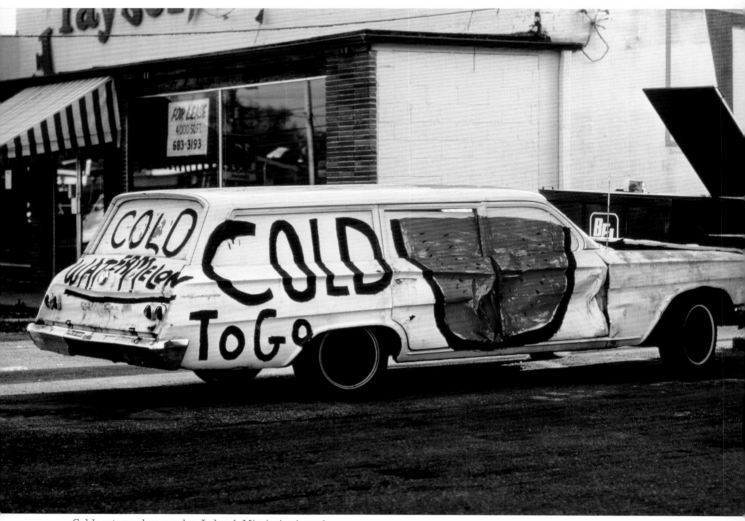

Cold watermelon vendor, Leland, Mississippi, 1976

102

ROADS TRAVELED

Working with my color photographs reminds me of how quickly my world has changed. Today, many of the people I photographed, their signs, and their buildings are gone. Change is inevitable, and the worlds in which I worked over the years have been transformed by the passage of time.

With that change in mind, I return regularly to the farm, the place I know best. I return to reconnect with family and friends, and I continue to photograph the people and the landscape that I have known longest.

These photographs underscore change. Many of the people whom I photographed— including my father, mother, and brother— have died. I think of them often and feel their presence in my life. Their memory endures through photographs and stories that we share about them. These photographs are how I respect and preserve their memory.

Bus barn, Vicksburg, Mississippi, summer 1976

Highway 61, Mississippi Delta, Mississippi, 1976

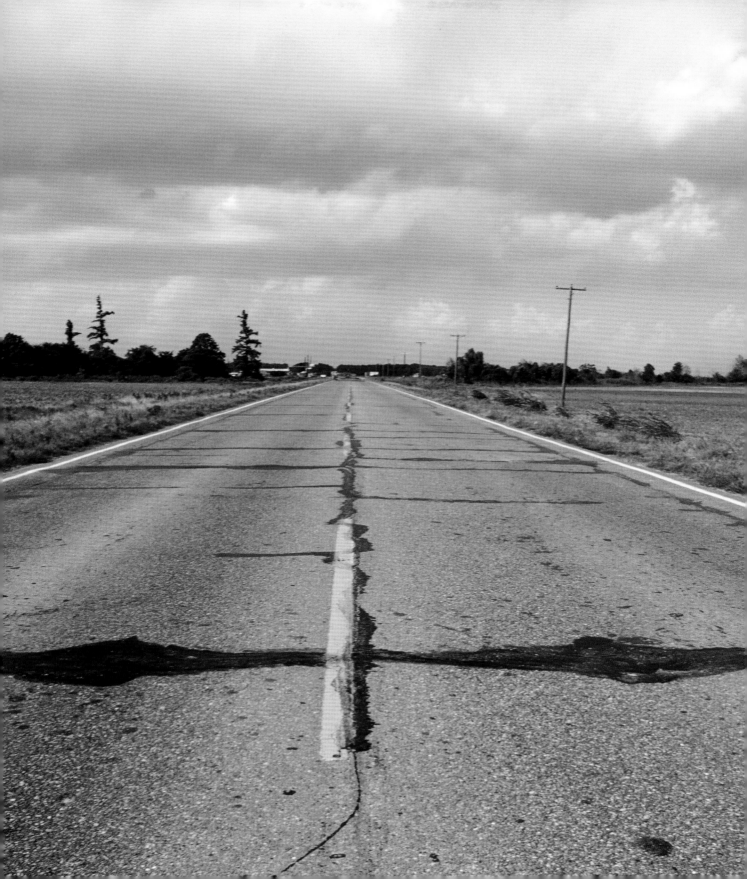

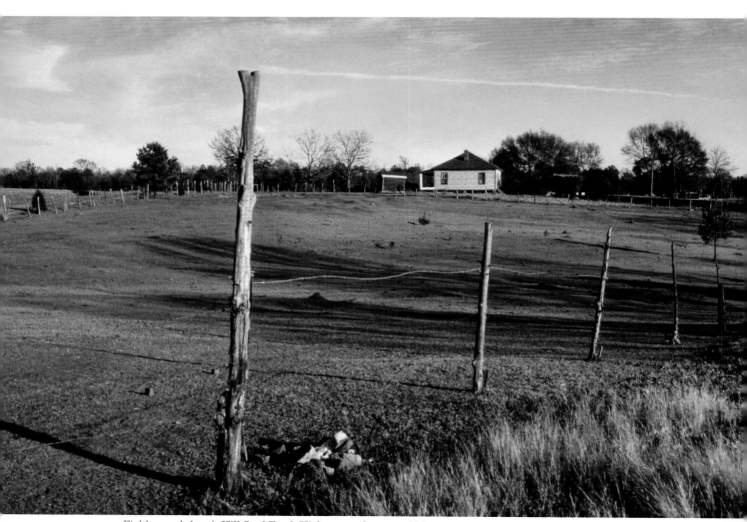

Field near Arlena's Hill Soul Food, Highway 27, between Utica and Crystal Springs, Mississippi, 1976

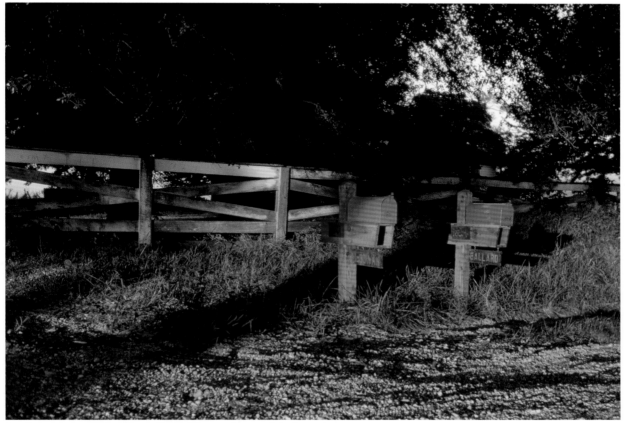

Mailboxes, 11188 Fisher Ferry Road, Warren County, Mississippi, 1976

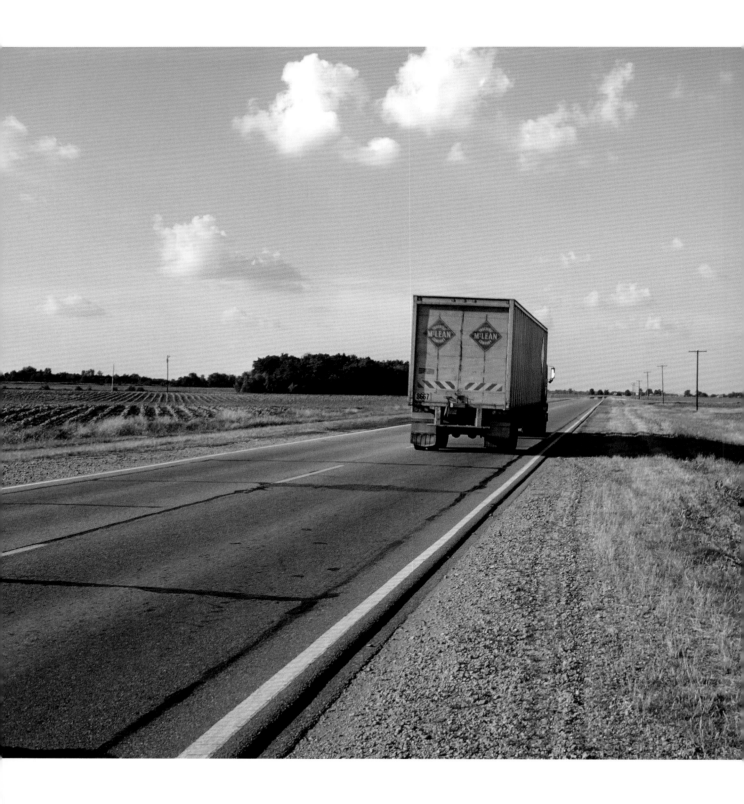

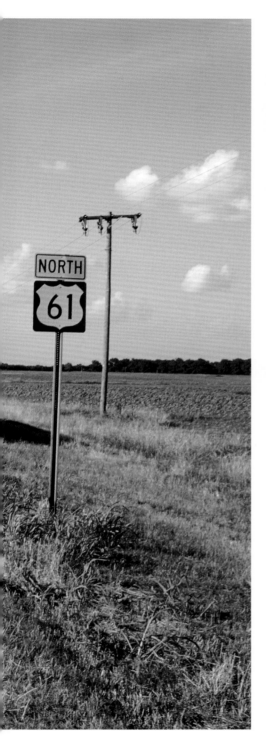

Kudzu, view from bus barn facing Belmont Street,
Vicksburg, Mississippi, 1976

Highway 61, Mississippi Delta, Mississippi, 1976

Home on Highway 27, between Utica and Crystal Springs, Mississippi, 1976

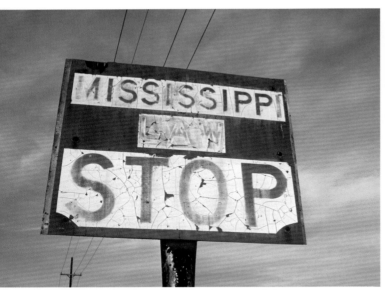

"Mississippi Law Stop" sign, Mississippi Delta, 1976

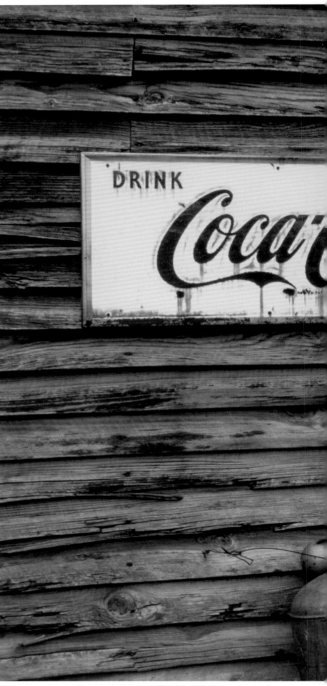

Country store, Old Port Gibson Road, Mississippi, 1976

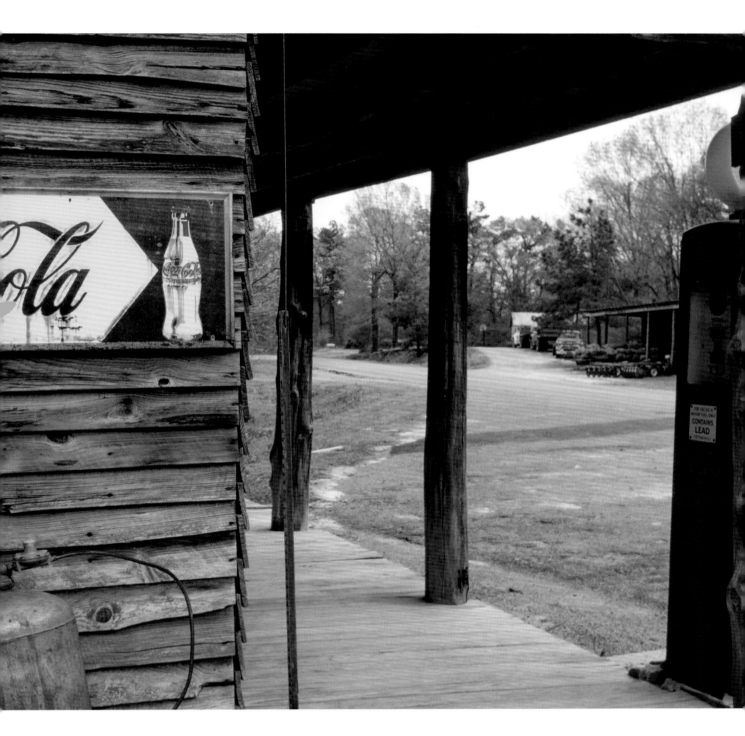

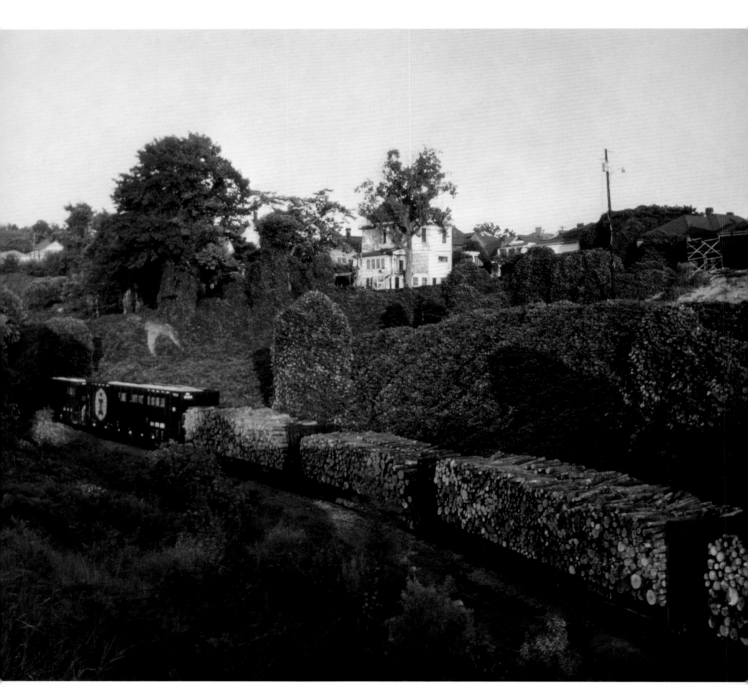

Kudzu and train with pulp wood, view from bus barn facing Belmont Street, Vicksburg, Mississippi, summer 1976

ACKNOWLEDGMENTS

This book is close to my heart. I am thrilled to see this highly curated collection of one hundred of my strongest photographs. This is the first book that focuses on my photography and particularly on my color images, published here for the first time. I am deeply grateful to Tom Rankin, professor of the practice of art and documentary studies and director of the MFA in Experimental and Documentary Arts at Duke University, who convinced me that my color photographs deserved to be recognized in this way, and to Elaine Maisner, senior executive editor at the University of North Carolina Press, who enthusiastically embraced the project.

Over the past five years, Gail Goers scanned contact sheets and color slides of more than 80,000 images, which are housed in my archive in the University of North Carolina's Southern Folklife Collection (SFC). Chris Fowler developed a process for marking and annotating the images we selected for the book. Once Gail had scanned all of my images, she, Beatrice Chauvin, Tom Rankin, Elaine Maisner, Virginia Thomas, and I each made a selection of color images that we thought were strongest.

I combined their suggested images with my own and asked Aaron Smithers, Southern Folklife assistant in the SFC, to make high-quality scans of each image. By that time, Gail had moved from Chapel Hill to enter the Rochester Institute of Technology's MFA program. At Susan Page's suggestion, I asked Diane Davis to help us complete the project. Diane, Patrick Horn, and I met with Aaron Smithers and Kerry Bannen, digitization workflow technician in the Digital Production Center in Wilson Library, to discuss our plan to make high-quality scans of each image.

My assistant Irene Newman worked tirelessly to locate the original color negatives and slides, which are housed in archival boxes in the SFC. Once Irene located the negatives and slides, she passed them to Aaron, who delivered the images to Kerry. Kerry then evaluated, analyzed, and scanned each negative or glass-mounted slide with her Hasseblad FlexTight X5. As she completed each scan, she loaded it onto an external drive.

Kerry patiently scanned over 600 images, from which we selected one hundred for this book. Those images were loaded onto a second external drive, which Diane Davis used to restore and retouch each image selected for the book. She examined each image in Adobe's Camera Raw software for tonal and color processing with careful attention to areas that had faded or been damaged over the years.

Diane retouched each digital file and did detailed retouching in Photoshop to address dust, scratches, and blemishes, and she also did color and tonal adjustments. She made a deliberate effort to maintain the characteristics of the original materials as her priority in this restoration process. Diane used software tools strategically to establish shadows and highlights for optimal reproduction.

Throughout this process—from the first idea for the book to its final arrival—Elaine Maisner was at my side and provided invaluable counsel. Elaine's creative suggestions and her firm reminders of our deadlines were always appreciated. This is the third book I have done with Elaine, and I always feel blessed to work with her.

Assistant editor Alison Shay, managing editor Mary Caviness, and manuscript editor Liz Gray worked closely with me to move the book forward in a smooth, seamless way. UNC Press director John Sherer and editorial director Mark Simpson-Vos are exemplary leaders who continue the Press's distinguished history of publishing books on the American South. Design director Kim Bryant and design and production manager Heidi Perov devoted

many hours to this book, and I am especially grateful to Richard Hendel for designing the volume. Dino Battista, Gina Mahalek, and Matthew Somoroff oversaw the marketing and promotion of the book. Ivis Bohlen, Ellen Bush, Joanna Ruth Marsland, and Vicky Wells also worked tirelessly on my behalf. It is a distinct honor to have my work published by the University of North Carolina Press and to work with its outstanding staff.

I received invaluable technical support from Paul Lamontagne and Ron Odum. Paul and Ron installed Adobe Lightroom, Adobe Bridge CS6, and Adobe Photoshop CS6 on my computer, which allowed me to work effectively with Diane Davis with whom I met on a regular schedule.

At the Center for Study of the American South, I received constant support and encouragement from my colleagues Renee Craft, Jeff DeLuca, Ayse Erginer, Patrick Horn, Kenneth Janken, Malinda Maynor Lowery, Irene Newman, Katy O'Brien, Rachel Olson, Karen Ortiz, Rachel Seidman, Dave Shaw, Deltra Tate, Jaycie Vos, Emily Wallace, Michelle Xia, and Katie Yelton.

To identify people in the photographs, I reached out to John Henry Wright and Diane Wright Smith for assistance with the Rose Hill congregation, to Billy Johnson for help with the Leland photographs, and to Maxine Barnes for identifying the Betcheimer Store. I am deeply grateful for their help with the book.

At Duke University, I received encouragement from Clare Callahan, Ph.D. candidate in the Department of English, and from Anna Kivlan, whose dissertation "Regionalism, Memory, and Photography in the Southern United States" in the Department of Art, Art History and Visual Studies resonated with this work.

Throughout this project Tom Rankin and Bruce Jackson have offered invaluable suggestions and encouragement. Their deep knowledge of photography and folklore moved this work forward in ways that I could never have imagined. Both are masters of photography and documentary arts, and Tom's generous foreword for the book frames the work in a beautiful, thoughtful way. Tom returns regularly with his camera to photograph Mississippi Delta worlds and is intimately familiar with many of the people and places featured in this book.

I am grateful to Tom Kenan and John Powell for their generous support of my work in general and of this book in particular. They both understand the study of the American South in deeply personal ways, and I feel blessed to be included in their circle of friends.

Emma Patterson, my literary agent, gave me invaluable counsel and support throughout this process. Emma is always encouraging of my projects, and I am grateful for her efforts on my behalf.

Ralph Willett wrote from his home in Dorset, England, with kind words about this book.

At every step of the way, Irene Newman has offered invaluable support. Irene's knowledge of technology, her thoroughness in dealing with editorial details, and her commitment to the book have been a gift beyond measure.

My siblings Shelby Fitzpatrick, Hester Magnuson, and Martha Ferris and their spouses Peter Fitzpatrick, Jim Magnuson, and Kos Kostmayer understand this work with their hearts. We share a deep bond of love for each other and for the worlds captured in these photographs.

My wife Marcie Cohen Ferris and our daughter Virginia Louise Ferris supported and encouraged my work on the book at every step. They are the loves of my life.

SELECTED BIBLIOGRAPHY

Agee, James, and Walker Evans. *Let Us Now Praise Famous Men*. New York: Ballantine Books, 1974.

Amberg, Rob. *Sodom Laurel Album*. Chapel Hill: University of North Carolina Press in association with the Center for Documentary Studies at Duke University, 2002.

Baldwin, Frederick, and Wendy Watriss. *Looking at the U.S.: 1957–1986*. Amsterdam: Mets & Schilt Publishers, 2009.

Bamberger, Bill. *Boys Will Be Men*. Flint, Mich.: Flint Institute of Arts, 2002.

Barilleaux, René Paul, ed. *Passionate Observer: Eudora Welty among Artists of the Thirties*. Jackson: Mississippi Museum of Art, 2002.

Belcher, Max, Beverly Buchanan, and William Christenberry. *House and Home: Spirits of the South*. Seattle: University of Washington Press, 1994.

Black, Patti Carr, ed. *Eudora*. Jackson: Mississippi Department of Archives and History, 1984.

———. *Mississippi Piney Woods: A Photographic Study of Folk Architecture*. Jackson: Mississippi Department of Archives and History, 1976.

Bryan, Sarah, and Peter Honig, eds. *Lead Kindly Light: Pre-War Music and Photographs from the American South*. Atlanta: Dust-to-Digital, 2014.

Burdine, Jane Rule. *Delta Deep Down*. Jackson: University Press of Mississippi, 2008.

Burke, Bill. *I Want to Take Picture*. Santa Fe, N.M.: Twin Palms Publishers, 2007.

———. *Mine Fields*. Atlanta: Nexus Press, 1995.

Charters, Ann, and Samuel Charters. *Blues Faces: A Portrait of the Blues*. Boston: David R. Godine, 2000.

Christenberry, William. *William Christenberry*. New York: Aperture, 2006.

Clay, Maude. *Mississippi History*. Gottingen, Germany: Steidl, 2015.

Clay, Maude, and Lewis Nordan. *Delta Land*. Jackson, University Press of Mississippi, 1999.

Clay, Maude, and Brad Watson. *Delta Dogs*. Jackson: University Press of Mississippi, 2014.

Cohen, John. *There Is No Eye: John Cohen Photographs*. New York: Powerhouse Books, 2001.

Dain, Martin. *Faulkner's County: Yoknapatawpha*. New York: Random House, 1964.

———. *Faulkner's World: The Photographs of Martin Dain*. Edited by Tom Rankin. Jackson: University Press of Mississippi, 1997.

Dow, Jim. *American Studies Photographs by Jim Dow*. Brooklyn: Powerhouse Books in association with the Center for Documentary Studies, 2011.

Eggleston, William. *The Democratic Forest*. Gottingen, Germany: Steidl, 2015.

———. *William Eggleston*. Goteborg, Sweden: Hasselblad Center, 1999.

———. *William Eggleston: Before Color*. Gottingen, Germany: Steidl, 2010.

———. *William Eggleston: Democratic Camera, Photographs, and Video, 1961–2008*. New Haven: Yale University Press, 2008.

———. *William Eggleston, 21/4*. Santa Fe, N.M.: Twin Palms Publishers, 1999.

———. *William Eggleston's Guide*. New York: Museum of Modern Art, 1976.

Eggleston, William (photographs), and Willie Morris (text). *Faulkner's Mississippi*. Birmingham: Oxmoor House, 1990.

Falco, Tav (author), and Alberto Garcia-Alix (contributor). *An Iconography of Chance: 99 Photographs of the Evanescent South*. Vienna, Austria: Elsinore Press, 2015.

Ferris, William. "Eudora Welty." In *The Storied South: Voices of Writers and Artists*, 23–42. Chapel Hill: University of North Carolina Press, 2013.

———. *Images of the South: Visits with Eudora Welty and Walker Evans*. Memphis, Tenn.: Center for Southern Folklore, 1977.

———. "Southern Literature: A Blending of Oral, Visual & Musical Voices." *Daedalus: Journal of the American Academy of Arts & Sciences* (Winter 2012): 139–53.

———. "Walker Evans." In *The Storied South: Voices of Writers and Artists*, 177–84. Chapel Hill: University of North Carolina Press, 2013.

———. "William Christenberry." In *The Storied South: Voices of Writers and Artists*, 185–89. Chapel Hill: University of North Carolina Press, 2013.

———. "William Eggleston." In *The Storied South: Voices of Writers and Artists*, 190–99. Chapel Hill: University of North Carolina Press, 2013.

Freeman, Roland L. *The Arabbers of Baltimore*. Centreville, Md.: Tidewater Publishers, 1989.

———. *A Communion of the Spirits: African-American Quilters, Preservers, and Their Stories*. Nashville, Tenn.: Thomas Nelson, 1996.

———. *The Mule Train: A Journey of Hope Remembered*. Nashville, Tenn.: Thomas Nelson, 1998.

———. *Pavements: Photographs of Black Americans*. New York: International Center of Photography, 1981.

Goode, James B. *Poets of Darkness*. Photographs by Vic Howard and Malcolm Jay Wilson. Jackson: University Press of Mississippi, 1981.

Gordon, Kevin. "Pecolia's Star" (song). *Gloryland* (CD). Kevin Gordon/Crowville Media, 2012.

Greenough, Sarah. *Looking In: Robert Frank's "The Americans."* Washington, D.C.: National Gallery of Art, 2009.

Greiner, William. *Show and Tell*. Lafayette: University of Louisiana at Lafayette Press, 2013.

Gruber, J. Richard. *William Christenberry: Art & Family*. New Orleans: Ogden Museum of Southern Art/University of New Orleans, 2000.

Hambourg, Maria Morris, Jeff L. Rosenheim, Douglas Eklund, and Mia Fineman. *Walker Evans*. New York: Metropolitan Museum of Art in association with Princeton University Press, 2000.

Hill, John. *Walker Evans: Lyric Documentary*. Gottingden, Germany: Steidl, 2006.

Hill, John, and Heinz Liesbrook, eds. *Walker Evans: Depth of Field*. New York: Prestel, 2015.

Jackson, Bruce. *Being There: Bruce Jackson Photographs 1962–2012*. Buffalo: Burchfield Penny Art Center, 2013.

———. *Cummins Wide: Photographs from the Arkansas Prison*. Durham and Buffalo: Center for Documentary Studies, Duke University & Center Working Papers, State University of New York at Buffalo, 2008.

———. *Inside the Wire: Photographs from Texas and Arkansas Prisons*. Austin: University of Texas Press, 2013.

Jackson, Bruce, and Diane Christian. *In This Timeless Time: Living and Dying on Death Row in America*. Chapel Hill: University of North Carolina Press in association with the Center for Documentary Studies at Duke University, 2012.

Kao, Deborah Martin, Laura Katzman, and Jenna Webster. *Ben Shahn's New York: The Photography of Modern Times*. New Haven: Yale University Press, 2000.

Katz, Joel. *And I Said No Lord: A Twenty-One-Year-Old in Mississippi in 1964*. Tuscaloosa: University of Alabama Press, 2014.

Kotz, Jack. *Ms. Booth's Garden*. Jackson: Mississippi Museum of Art, 2002.

Laub, Gillian. *Southern Rites*. Bologna, Italy: Damiani, 2015.

Leibovitz, Annie, and Patti Smith. *American Music*. New York: Random House, 2003.

Light, Ken. *Delta Time: Mississippi Photographs by Ken Light*. Washington, D.C.: Smithsonian Institution Press, 1995.

Livingston, Jane. *The New York School Photographs: 1936–1963*. New York: Stewart, Tabori & Chang, 1992.

Lomax, Alan, and Bruce Jackson. *Parchman Farm: Photographs and Field Recordings: 1947–1959*. Atlanta: Dust-to-Digital, 2015.

Lyon, Danny. *Knave of Hearts*. Santa Fe, N.M.: Twin Palms Publishers, 1999.

———. *Memories of the Southern Civil Rights Movement*. Santa Fe, N.M.: Twin Palms Publishers, 2010.

Mann, Sally. *Hold Still: A Memoir With Photographs*. Boston: Little, Brown, 2015.

Mauskopf, Norman, and Randall Kenan. *A Time Not Here: The Mississippi Delta*. Santa Fe, N.M.: Twin Palms Publishers, 1997.

McDaris, Wendy, ed. *Visualizing the Blues*. Memphis, Tenn.: Dixon Gallery and Gardens, 2000.

McPherson, Sandra. "Holy Woman: Pecolia Warner." In *The God of Indeterminacy: Poems*, 29. Champaign-Urbana: University of Illinois Press, 1993.

Mora, Gilles, and John T. Hill. *Walker Evans: The Hungry Eye*. New York: Harry N. Abrams, 1993.

Parks, Gordon. *Gordon Parks: Segregation Story*. Gottingen, Germany: Steidl, 2015.

Phillips, Sandra S., ed. *Eudora Welty as Photographer*. Jackson: University Press of Mississippi, 2009.

Ramsey, Frederic, Jr. *Been Here and Gone*. Athens: University of Georgia Press, 2000.

Rankin, Tom, ed. *"Deaf Maggie Lee Sayre": Photographs of a River Life*. Jackson: University Press of Mississippi, 1995.

———. *Faulkner's World: The Photographs of Martin J. Dain*. Jackson and Oxford: University Press of Mississippi and Center for Study of Southern Culture, University of Mississippi, 1997.

———. *One Place: Paul Kwilecki and Four Decades of Photographs from Decatur County, Georgia*. Chapel Hill: University of North Carolina Press in association with the Center for Documentary Studies at Duke University, 2013.

———. *Sacred Space: Photographs from the Mississippi Delta*. Jackson: University Press of Mississippi, 1993.

Robbins, Kathleen. *Into the Flatland*. Columbia: University of South Carolina Press, 2015.

Rosenheim, Jeff. *Walker Evans and the Picture Postcard*. New York: Steidl/Metropolitan Museum of Art, 2009.

———. *Walker Evans: Polaroids*. Berlin: Scalo Zurich in association with the Metropolitan Museum of Art, 2002.

Sartor, Margaret, and Geoff Dyer. *What Was True: The Photographs and Notebooks of William Gedney*. New York: Center for Documentary Studies in association with W. W. Norton, 1999.

Soth, Alec. *Gathered Leaves*. London: Mack, 2015.

Stack, Trudy Wilner. *Christenberry Reconstruction: The Art of William Christenberry*. Jackson: University Press of Mississippi, 1996.

Steele, Alysia Burton. *Delta Jewels: In Search of My Grandmother's Wisdom*. New York: Center Street, 2015.

Sussman, Elisabeth, and Thomas Weski. *William Eggleston: Democratic Camera, Photographs and Video, 1961–2008*. New York: Whitney Museum of American Art, 2009.

Theroux, Paul, and Steve McCurry (photographer). *Deep South: Four Seasons on Back Roads*. New York: Houghton Mifflin Harcourt, 2015.

Walker, James Perry. *The Reverend*. Jackson: University Press of Mississippi, 2006.

Waterman, Dick. *Between Midnight and Day: The Last Unpublished Blues Archive*. New York: Thunder's Mouth Press, 2003.

Watriss, Wendy, and Fred Baldwin. *Coming to Terms: The German Hill Country of Texas*. College Station: Texas A&M University Press, 1991.

Welty, Eudora. *Country Churchyards*. Jackson: University Press of Mississippi, 2000.

———. *Eudora Welty Photographs*. Jackson: University Press of Mississippi, 1989.

———. *Some Notes on River Country*. Jackson: University Press of Mississippi, 2003.

West, Bruce. *The True Gospel Preached Here*. Foreword by Tom Rankin. Jackson: University Press of Mississippi, 2014.

Williams, Lucinda. "Get Right With God" (song and photograph). *Essence* (CD). Lost Highway, 2001.

Withers, Ernest. *Negro Baseball League*. New York: Harry N. Abrams, 2005.

Withers, Ernest, and Jack F. Hurley. *Pictures Tell the Story: Ernest C. Withers Reflections in History*. Norfolk, Va.: Chrysler Museum of Art, 2000.

Withers, Ernest, and Daniel Wolff. *The Memphis Blues Again: Six Decades of Memphis Music Photographs*. New York: Viking Studio, 2001.

H. EUGENE AND LILLIAN YOUNGS LEHMAN SERIES

Lamar Cecil, *Wilhelm II: Prince and Emperor, 1859–1900* (1989).

Carolyn Merchant, *Ecological Revolutions: Nature, Gender, and Science in New England* (1989).

Gladys Engel Lang and Kurt Lang, *Etched in Memory: The Building and Survival of Artistic Reputation* (1990).

Howard Jones, *Union in Peril: The Crisis over British Intervention in the Civil War* (1992).

Robert L. Dorman, *Revolt of the Provinces: The Regionalist Movement in America* (1993).

Peter N. Stearns, *Meaning Over Memory: Recasting the Teaching of Culture and History* (1993).

Thomas Wolfe, *The Good Child's River, edited with an introduction by Suzanne Stutman* (1994).

Warren A. Nord, *Religion and American Education: Rethinking a National Dilemma* (1995).

David E. Whisnant, *Rascally Signs in Sacred Places: The Politics of Culture in Nicaragua* (1995).

Lamar Cecil, *Wilhelm II: Emperor and Exile, 1900–1941* (1996).

Jonathan Hartlyn, *The Struggle for Democratic Politics in the Dominican Republic* (1998).

Louis A. Pérez Jr., *On Becoming Cuban: Identity, Nationality, and Culture* (1999).

Yaakov Ariel, *Evangelizing the Chosen People: Missions to the Jews in America, 1880–2000* (2000).

Philip F. Gura, *C. F. Martin and His Guitars, 1796–1873* (2003).

Louis A. Pérez Jr., *To Die in Cuba: Suicide and Society* (2005).

Peter Filene, *The Joy of Teaching: A Practical Guide for New College Instructors* (2005).

John Charles Boger and Gary Orfield, eds., *School Resegregation: Must the South Turn Back?* (2005).

Jock Lauterer, *Community Journalism: Relentlessly Local* (2006).

Michael H. Hunt, *The American Ascendancy: How the United States Gained and Wielded Global Dominance* (2007).

Michael Lienesch, *In the Beginning: Fundamentalism, the Scopes Trial, and the Making of the Antievolution Movement* (2007).

Eric L. Muller, *American Inquisition: The Hunt for Japanese American Disloyalty in World War II* (2007).

John McGowan, *American Liberalism: An Interpretation for Our Time* (2007).

Nortin M. Hadler, M.D., *Worried Sick: A Prescription for Health in an Overtreated America* (2008).

William Ferris, *Give My Poor Heart Ease: Voices of the Mississippi Blues* (2009).

Colin A. Palmer, *Cheddi Jagan and the Politics of Power: British Guiana's Struggle for Independence* (2010).

W. Fitzhugh Brundage, *Beyond Blackface: African Americans and the Creation of American Mass Culture, 1890–1930* (2011).

Michael H. Hunt and Steven I. Levine, *Arc of Empire: America's Wars in Asia from the Philippines to Vietnam* (2012).

Nortin M. Hadler, M.D., *The Citizen Patient: Reforming Health Care for the Sake of the Patient, Not the System* (2013).

Louis A. Pérez Jr., *The Structure of Cuban History: Meanings and Purpose of the Past* (2013).

Jennifer Thigpen, *Island Queens and Mission Wives: How Gender and Empire Remade Hawai'i's Pacific World* (2014).

George W. Houston, *Inside Roman Libraries: Book Collections and Their Management in Antiquity* (2014).

Philip F. Gura, *The Life of William Apess, Pequot* (2015).

Daniel M. Cobb, ed., *Say We Are Nations: Documents of Politics and Protest in Indigenous America since 1887* (2015).

Daniel Maudlin and Bernard L. Herman, eds., *Building the British Atlantic World: Spaces, Places, and Material Culture, 1600–1850* (2016).

William Ferris, *The South in Color: A Visual Journal* (2016)